POSTCARD HISTORY SERIES

Around Pottstown

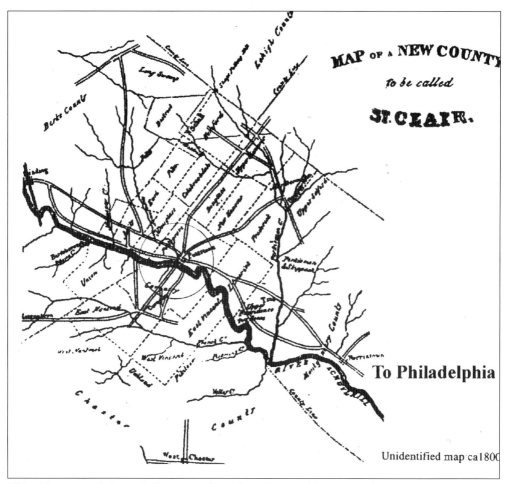

This old map, with its circled area, is a basic foundation of the area to be covered by this book.

POSTCARD HISTORY SERIES

Around Pottstown

Patricia Wanger Smith

ARCADIA

First published 2004
Reprinted 2004

Published by Arcadia Publishing,
Charleston SC, Chicago IL, Portsmouth NH, San Francisco CA

Printed in Great Britain

Library of Congress Catalog Card Number: 2002114293

For all general information, contact Arcadia Publishing:
Telephone 843-853-2070
Fax 843-853-0044
E-mail sales@arcadiapublishing.com
For customer service and orders:
Toll-free 1-888-313-2665

Visit us on the Internet at www.arcadiapublishing.com

This postcard was sent in 1908 to Kate Grubb, the author's great-grandmother, by her granddaughter Gertrude.

CONTENTS

Introduction 7

1. The Pottstown Business Section 9

2. Transportation and Industry 43

3. Area Schools 61

4. Area Churches 71

5. Civic and Service Groups 83

6. Pastimes, Recreation, and Celebrations 93

7. Our Homes and Villages 115

Acknowledgments 128

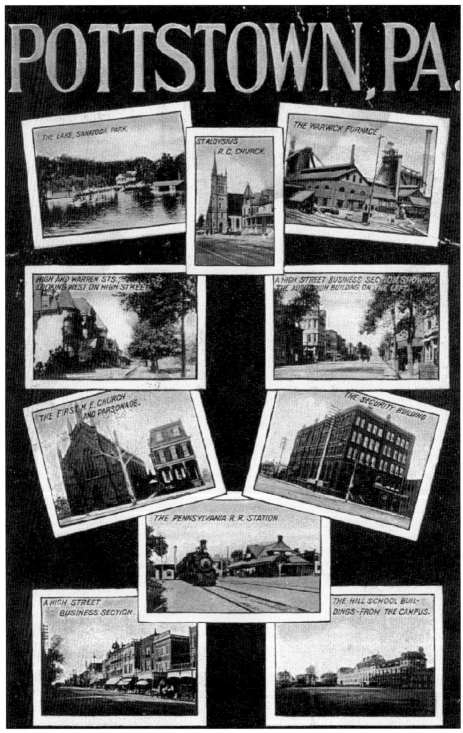

This card offers greetings from Pottstown, Pennsylvania, a history buff's paradise. Join us as we reminisce about the golden era of the early 20th century by way of vintage postcards and photographs.

INTRODUCTION

Pottstown is located on the banks of the Schuylkill River about 35 miles west of Philadelphia and about 20 miles east of Reading. Its earliest settlers were from Europe, and these people included English, German, French, Swiss, and Welsh. The town itself was laid out as Pottsgrove by John Potts in 1752. John Potts was a noted industrialist tied by marriage to the Rutters, Savages, and Nutts, the earliest iron industrialists of the Colonial period of the United States. It is these forgers who filled the people's needs for stoves and household wares and supplied the Revolutionary War soldiers with cannons, cannonballs, and other useful products of iron. Potts's land was received by land grants from the William Penn family.

The earliest inhabitants of the region were the Lenni Lenape Native Americans with whom French Canadian fur traders Pierre Bizaillion and Jacque LeTort did business c. 1700. History tells us that they had a small trading post on the south (North Coventry) side of the Schuylkill River, near what is now Kenilworth. They lived in and reportedly hid their merchandise in caves located between today's Pottstown Landing to today's Spring City, downriver.

Pottstown was a bustling, growing, primarily industrial town at the beginning of the 20th century. A few of the nationally known industries to emerge before the mid-20th century included Mrs. Smith's Pies, Bethlehem Steel, U.S. Axle, Dana Corporation, Doehler-Jarvis, Firestone, Gudebrod, and many others. The town still boasts a retail men's store that is one of the oldest family-owned stores in the United States. The Pottstown Roller Mills business has been providing feed for farm animals on both sides of the river since 1725.

It is a little-known fact that in 1783, 1795, 1805, and 1814, it was proposed to the Pennsylvania General Assembly that a new county should be created and named St. Clair with Pottsgrove (Pottstown) as its county seat. This area would have roughly encompassed northern Chester County, western Montgomery County, and eastern Berks County. According to writings of local historian and genealogist George F. P. Wanger, the author's grandfather, this idea again surfaced at the beginning of the 20th century. "Why call this new proposition St. Clair?" you might ask. Revolutionary War major general Arthur St. Clair resided in Pottsgrove (Pottstown) in 1785, when he was elected to the Continental Congress, of which he became the president in 1787. This was the highest governing office at that time in the life of the young country.

People not only worked in Pottstown in the first half of the 20th century but played there as well. Some of the many places for fun and recreation were Ringing Rocks Park, a local attraction of an ice-age deposit of rocks that actually ring when struck with a hammer; Sanatoga Park, with its fine lake, amusements, and bandstand; and the famous Sunnybrook Ballroom, where thousands were entertained by the musical greats in the mid-20th century.

This book will flesh out the information given in brief here with many more facts and local color. It covers a period from the late 19th century to the mid-20th century by the use of postcards, words, and a few pictures of the area. The materials will explore Pottstown, Stowe, and Sanatoga—all of which share the same zip code—and their neighbors across the river, North Coventry and East Coventry Townships. Many of the residents of these townships also carry a Pottstown address. These areas are an integral part of Pottstown's history, people, and culture and religious, educational, industrial, and agricultural enterprises.

Just a bit of information before we go on: the Post Office Department (later known as the U.S. Postal Service) did not authorize a divided back on postcards until 1907. Hence, I will refer to pre-1907 postcards as having undivided backs. Occasionally, you will see that folks wrote on the front of the card, as they had nowhere else to write.

It is my sincere wish that, should you be interested in more in-depth histories of the Pottstown area, you will read the Chancellor and Wendell *History of Pottstown 1752–1952*. For those readers interested in an extremely well done history of the Coventries, please read Estelle Cremers's *Coventry, the Skool Kill District,* published in 2003.

This book is not meant to be a historical treatise of the area but rather "eye candy" glimpses of life in the first half of the 20th century, with appropriate captions, facts, and a bit of lore. Please enjoy and savor our past.

One

The Pottstown
Business Section

Pottsgrove Manor, built *c.* 1752, was the home of John Potts, the founder of Pottstown. During the Revolutionary War, it was reportedly Washington's headquarters for a short period of time. This 1908-postmarked card indicates that it was the Mill Park Hotel. In back of the hotel were open fields where now there is a shopping mall and a super highway. It was on those fields, called Mill Park, that horse races and later automobile races were held in the early 20th century. When circuses came to town, they were frequently held in this area up until the 1950s.

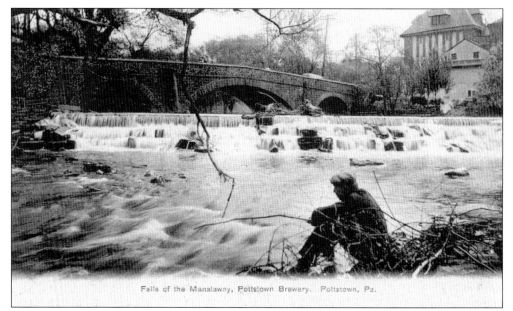

Falls of the Manatawny, Pottstown Brewery. Pottstown, Pa.

This bridge, over the Manatawny Creek on High Street leading into town, was built in 1805 and operated as a toll bridge until 1841. In this 1906 postcard we see the falls caused by the dam of the Manatawny Creek and the old Pottstown Brewery building. The bridge was replaced in 1909. The dam was recently destroyed, as it was felt that it contributed to the flooding of Manatawny Park during high-water intervals.

The Owls Home sat in the 100 block of High Street. It appears that this building was an old mansion prior to becoming the group's home.

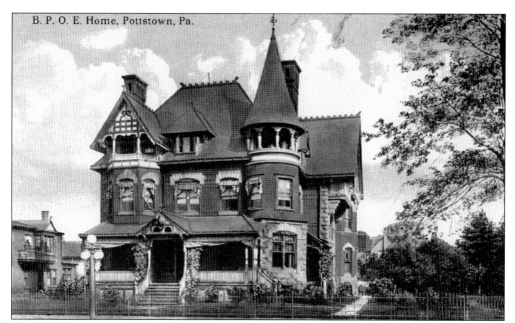

B. P. O. E. Home, Pottstown, Pa.

This lovely old mansion from the Victorian era is located on the north side of High Street between York and Manatawny Streets. It has become the home of the Elks Club and continues to host many of Pottstown's social functions. This building was the former Fegely mansion. The VanBuskirk family home formerly stood on these grounds.

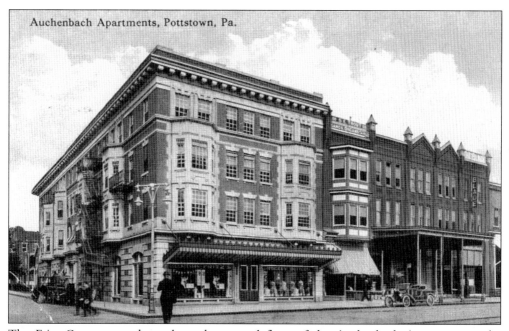

Auchenbach Apartments, Pottstown, Pa.

The Fritz Grocery was located on the ground floor of the Auchenbach Apartments at the northeast corner of High and York Streets. This 1912 building still stands, as do the stores seen on the right. Many of the buildings have been recently rehabbed and host a variety of stores and restaurants.

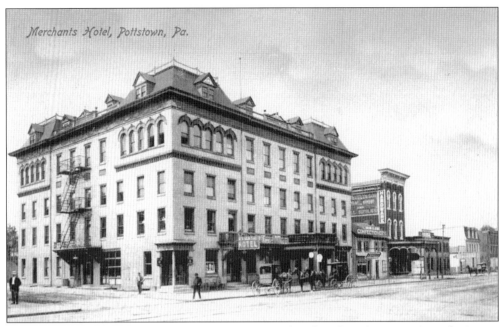

The Merchants Hotel stood on the southwest corner of High and York Streets. A confectionery shop is seen on the right, and the J. Fegely and Son hardware, lumber, and coal store is the tallest edifice with an overhang. The hotel was erected on this site *c.* 1845 and was razed *c.* 1960 to make way for an eating establishment that remains on the spot today.

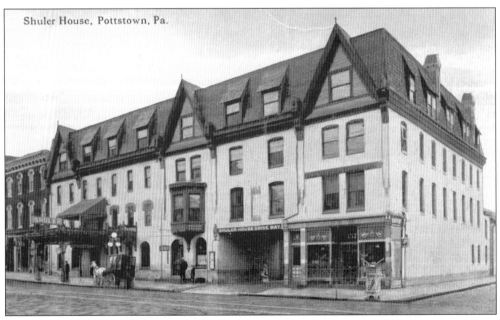

Just up High Street, on the south side, was the Shuler House, a grand hotel and restaurant operated in the 20th century by the Govatos family until it was razed during the urban renewal period of the late 20th century. The land on which it sat is now part of the city hall park complex. Prior to the Shuler House, the lot held the Farmers Hotel.

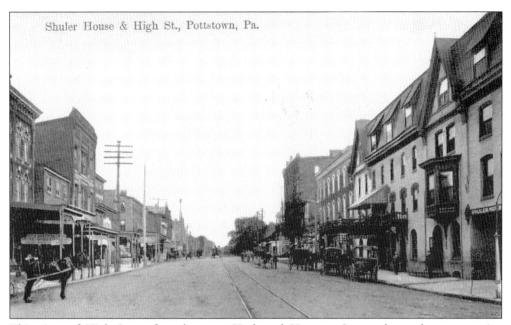

Shuler House & High St., Pottstown, Pa.

This view of High Street from between York and Hanover Streets shows the many active businesses of the day, including the Hallman Feed Store (left). Some of the building facades remain today. Also note the trolley tracks. There are no horseless carriages, so we may safely assume that this card dates from *c.* 1910.

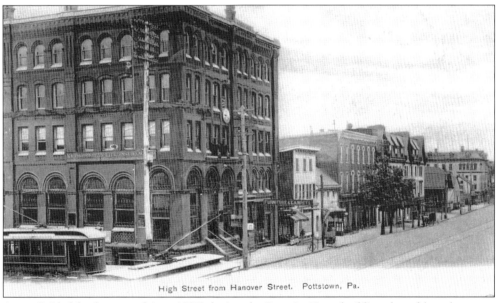

High Street from Hanover Street. Pottstown, Pa.

An undivided-back postcard (pre-1907) depicts the Security Trust building that, although vacant, still stands. It was built in 1887 by Jacob Fegely. What a grand bank it was in its time, with marble counters and brass tellers' shields! The upper floors held the offices of some of Pottstown's finest professionals.

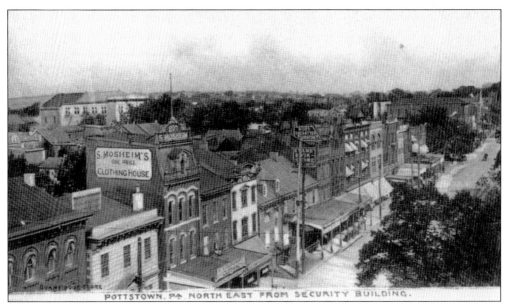

This shot, taken in 1906 or earlier, looks up at the north side of High Street from Hanover toward Penn Street. S. Mosheim's Clothing House stands out, but with magnification, Root the Hatter and the Evans Book Store are visible.

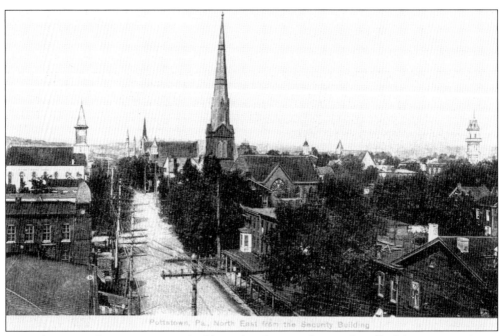

Again from atop the Security Trust building, the photographer catches all of the Hanover Street churches—Trinity Reformed, Transfiguration Lutheran, the Old Brick Church, Emanuel Lutheran, and St. Aloysius.

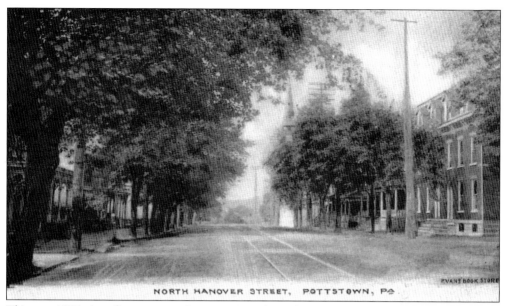

This pre-1907 view from a ground perspective of North Hanover Street reveals the residences between Walnut and Beech Streets. Many of these homes still remain.

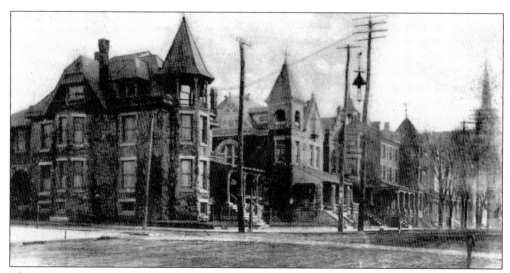

This view looks in the opposite direction, north to south on Hanover Streets. We are able to admire the many magnificent dwellings on the east side of Hanover Street, looking from Beech Street, with Emanuel Lutheran Church in the background.

15

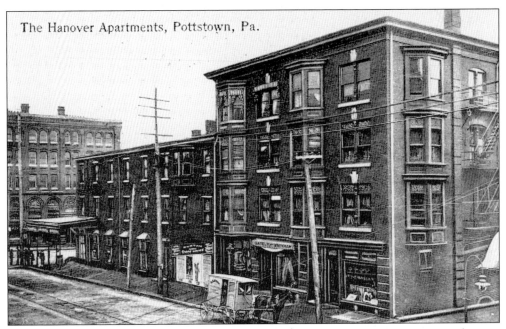

The Hanover Apartments, Pottstown, Pa.

Returning from our stroll out Hanover Street, we see the Hanover Street Apartments on the west side, near High Street. A delivery wagon from the Fairview Dairy Farm is seen. The white building in the center is the Boston Shoe Store, where the highest-priced shoe is $1. The store may have been closed or have had another entrance, as there is a poster covering the front, advertising a black minstrel show.

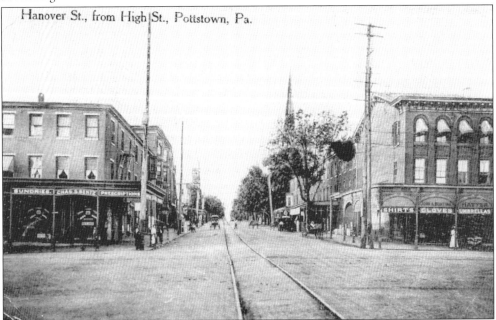

Hanover St., from High St., Pottstown, Pa.

As we reach High Street, we again look back up Hanover to catch the corner establishments of the C. J. Bentz Drug Store and the Bunting's clothing store. Bentz's was a popular lunch spot for high school students in the 1950s, and Bunting held the distinction of being Pottstown's oldest clothing store, with about 175 years of service until its closure in the 1970s.

16

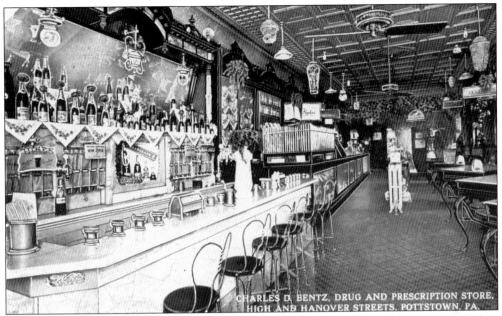

Seen is the interior of the C. J. Bentz Drug Store, replete with a fantastic ice-cream soda bar. Note the lovely ice-cream chairs and the dated radiator in the middle of the establishment.

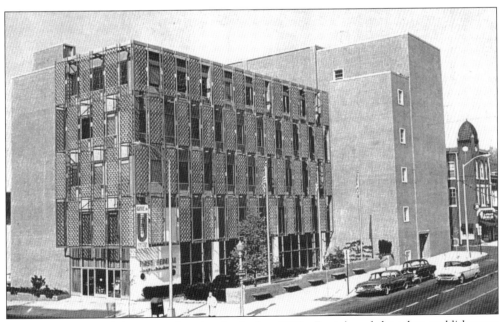

Progress is progress, it is supposed, and so in the late 1950s, Bentz's and the other establishments on the northwest corner of High and Hanover Streets were demolished to erect this modern edifice, which with some modifications remains today.

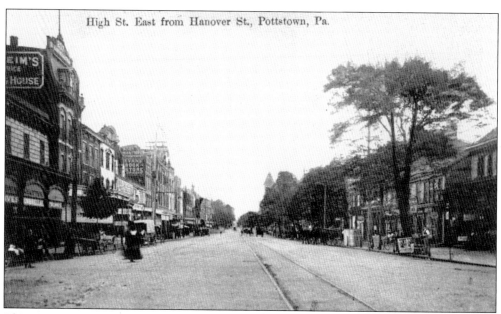

High St. East from Hanover St., Pottstown, Pa.

This 1910 view looks east on High Street from Hanover Street.

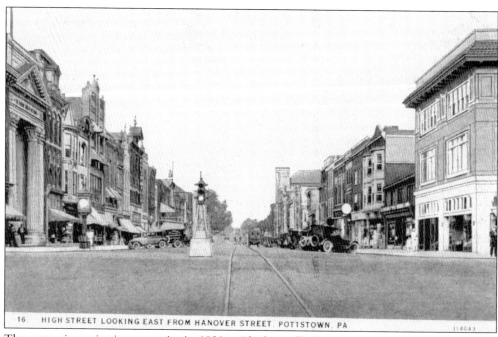

16. HIGH STREET LOOKING EAST FROM HANOVER STREET. POTTSTOWN. PA.

The same viewpoint is seen again, in 1939, with the traffic light in the center of the street and the clocks on either side of the street. The bank building with pillars on the left still operates as a bank, although many changes to its facade have been made over the years.

18

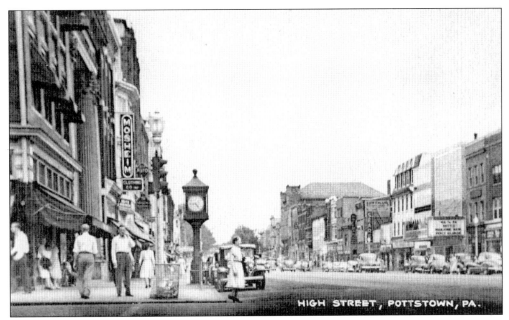

We see the same view *c.* 1949, with the Sears store mid-block on the right, or south, side of High Street. Also on that side are Hoffman's Dress Shop and the newer Hippodrome Theater, where *Ma and Pa Kettle* is playing.

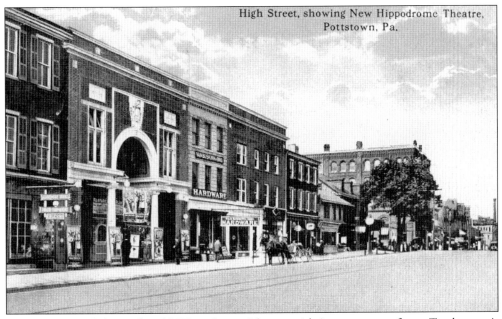

This *c.* 1917 card shows the old Hippodrome Theater with its posters out front. To the east is the C. W. Lessig store, which sold dry goods and groceries. The VanBuskirk hardware store is to the right of the theater. VanBuskirk's was a staple of the Pottstown business community for well over 100 years. At the corner, the building with dormers is the St. Clair building.

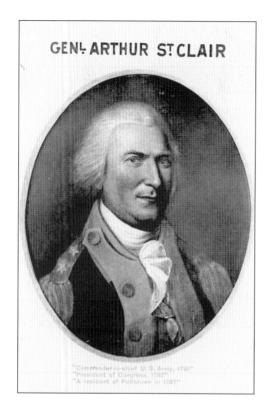

GENL. ARTHUR ST. CLAIR

"Commander-in-chief U. S. Army, 1791"
"President of Congress, 1787"
"A resident of Pottstown in 1787"

Finally, we get to meet Maj. Gen. Arthur St. Clair, mentioned in the introduction. He left the town in 1787 to assume his position as president of the Continental Congress.

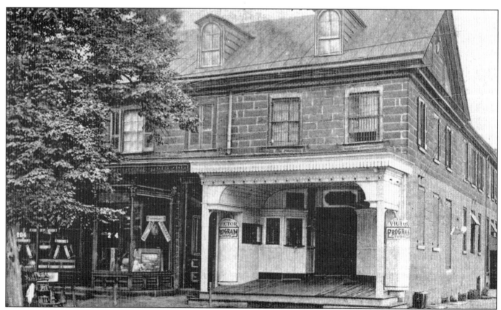

This was St. Clair's home, at the southeast corner of High and Hanover Streets, as photographed by Edward D. Rhoads. The mansion was originally built by one of John Potts's sons who was a British sympathizer. It is assumed that his property was confiscated after the Revolutionary War. From a mansion in the 1700s, it became an early Victor movie theater prior to 1920, as seen here. Today, this building is gone, but ironically the new one houses an audio and video store.

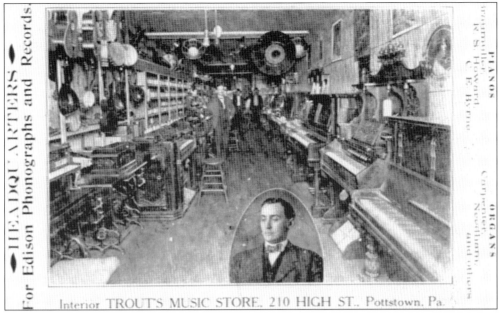

This wonderful interior view of the Trout Music Store shows pianos and all sorts of phonographs for the home. Note the huge morning glory speakerphone hanging in the center of the store. The store stood near to the corner of High and Hanover Streets prior to 1907.

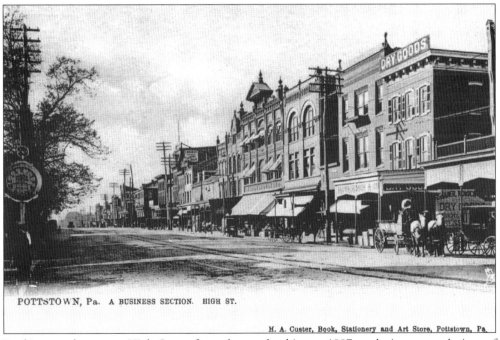

Looking northwest on High Street from the south, this pre-1907 card gives a good view of Shaner, Romich and Company, which sold dry goods. The Ellis Mills building is mid-block. That business also graced Pottstown for over 100 years. The clock on the left advertises a jeweler's establishment.

A real photo postcard judged to be *c.* 1910 shows the interior of the Shaner, Romich and Company dry goods store during the Christmas season. Each of those fancy signs advertises something different for sale. This store stood on the northwest corner of High and Penn, where Boyer's Shoes was for many years.

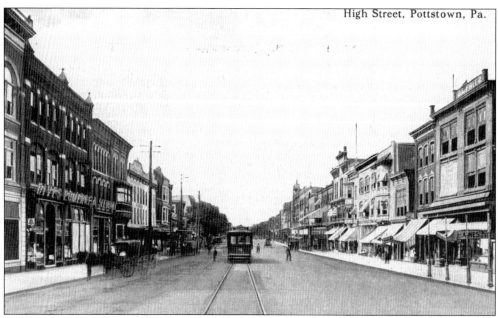

The view in this 1914 card looks west on High Street and shows the Dives, Pomeroy and Stewart department store. From this business, the Pomeroy's stores emerged. Pomeroy's later became what we know now as the Bon-Ton stores (of course, not in this location). The J. C. Penney store was here in the 1940s and 1950s. That store had a track around the store ceiling to carry the money to the office where the cashiers made change.

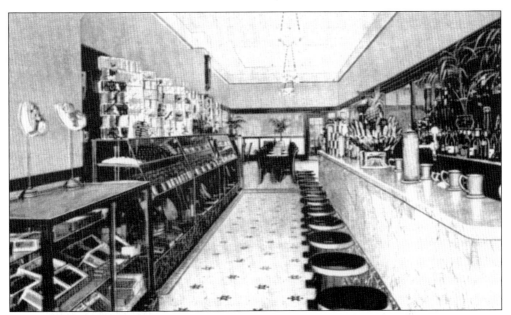

Also on the south side of High Street was the Pottstown Candy Kitchen. The rich confectionery delights abound in the front cases. The ceiling featured the pressed decorative tin of the times.

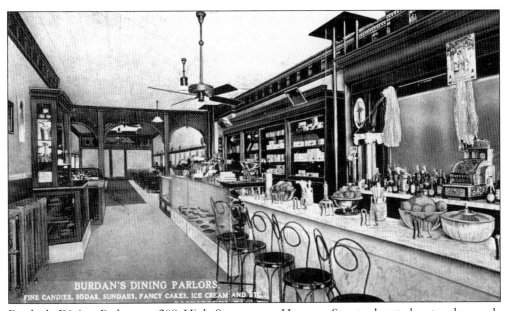

Burdan's Dining Parlor—at 209 High Street, near Hanover Street—boasted not only a soda fountain but also a restaurant.

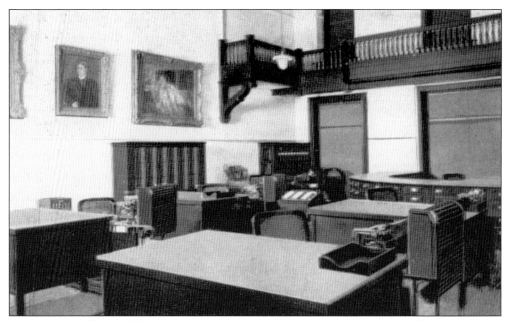

J. Bernhart's office building was just east of Burdan's. Note the modern office equipment. Bernhart's housed the Mutual Fire Insurance Company of Chester County *c.* 1918.

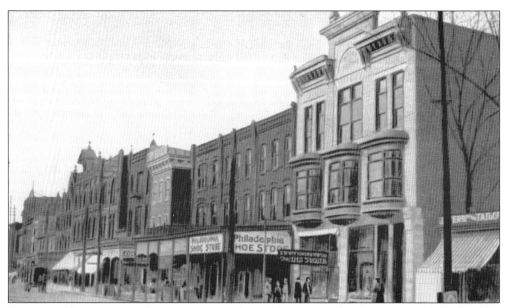

Coupled with the next card, we see an evolution of the same business area on north High Street between 1908 and 1920. J. Erb, the tailor, is seen on the right. Rocesh Brothers opened a cigar store in 1907 in the larger lighter-colored building in the picture.

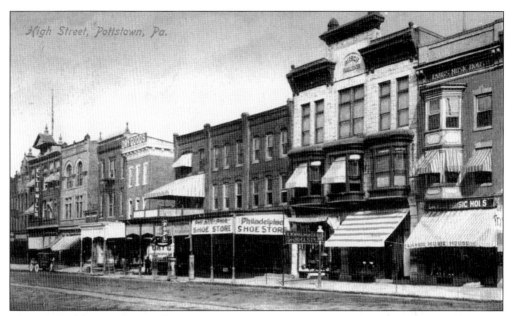

This view of the north side of High Street from *c.* 1920 shows Ellis Mills to the left, a pool hall, the Philadelphia Shoe Store, the F. W. Woolworth store, and the new Lamb's Music House. The Lamb family had a great impact on the musical history of the 20th century in Pottstown.

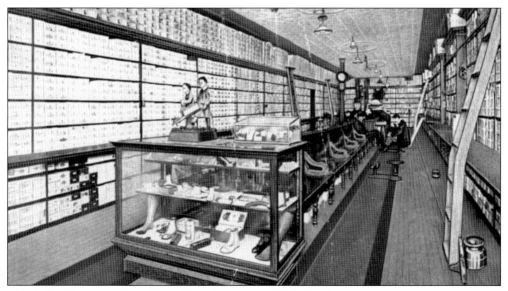

This is the Common Sense Shoe Store, located on High Street.

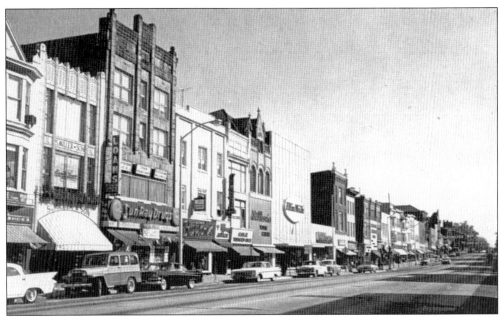

A *c.* 1960 photo postcard by Gene Orlando reveals the north side of High Street, as remembered by many of us older folks from our youth.

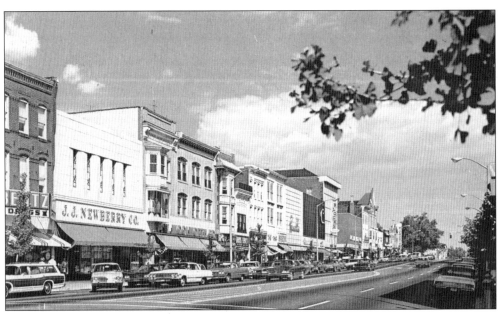

This is another 1960s photographic view of the north side of High Street taken by Orlando. In referring back to a previous picture, it is obvious that F. W. Woolworth has moved to the east, and the J. J. Newberry store has a new building, where Woolworth's had once been before a fire in the 1940s.

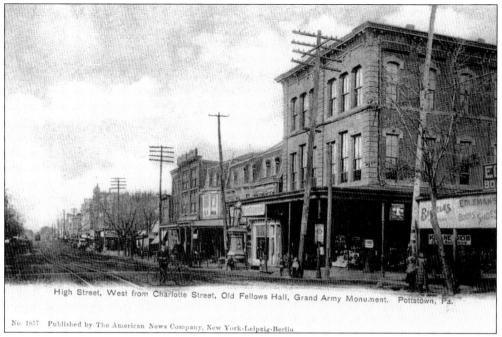

High Street, West from Charlotte Street, Old Fellows Hall, Grand Army Monument. Pottstown, Pa.

No 1857 Published by The American News Company, New York-Leipzig-Berlin

The next few cards will follow a progressive theme. This pre-1907 postcard view looks at the north corners of High and Charlotte Streets. The building that has been a furniture store for at least 75 years housed the Odd Fellows hall on the third floor prior to 1907. Diener's Bicycle Shop is across Charlotte Street, as is Edleman's Boots and Shoes.

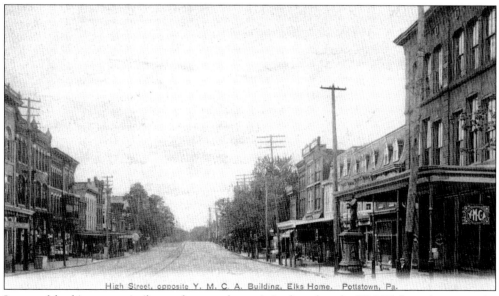

High Street, opposite Y. M. C. A. Building, Elks Home. Pottstown, Pa.

In a card looking very similar to the one above, it is clear that the YMCA has taken over the Odd Fellows hall. The Grand Army of the Republic statue is directly out front. That statue was restored c. 2000 and moved one block east on High Street.

27

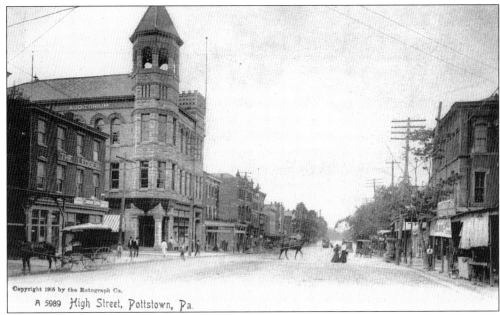

A 5989 High Street, Pottstown, Pa.

The magnificent Auditorium was built in 1904. In the 1920s, it became the Bahr Arcade and stood directly across High Street from the previous views. This is a pre-1907 postcard, and the Ledger, or Common Sense, building, home to a newspaper enterprise until 1920, is seen just to the left of the Bahr building. The Ledger corner once housed the Pep Boys store and most recently became part of the farmer's market complex.

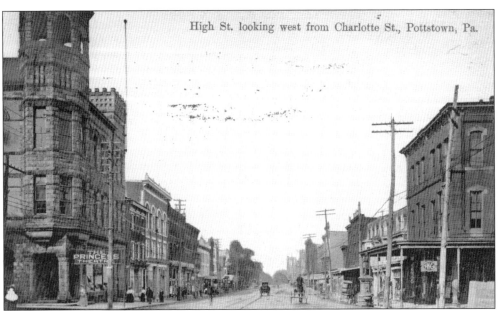

High St. looking west from Charlotte St., Pottstown, Pa.

A bit later, in a 1910 or 1911 view, is the Princess Theater advertising outside the Auditorium building. After 1920, the Bahr building at various times was home to the farmer's market, a delicatessen, a jewelry store, a stationery store, a confectionery store, a hair dressing salon, professional offices, and plush apartments. In the late 20th century, the building was deemed too costly to maintain and was razed to make way for a parking lot.

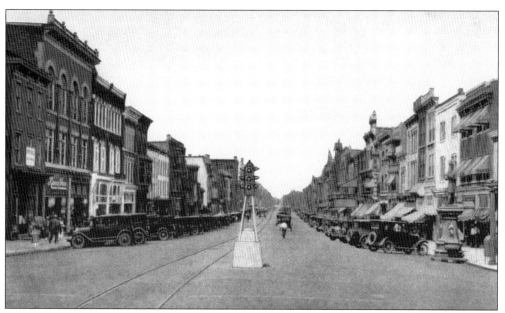

This card must be from the 1920s with all the Model T Fords in abundance. The streets are paved, and a traffic light is in the middle of the street. Kinney's shoe store is seen on the left and remained there until *c.* the 1960s.

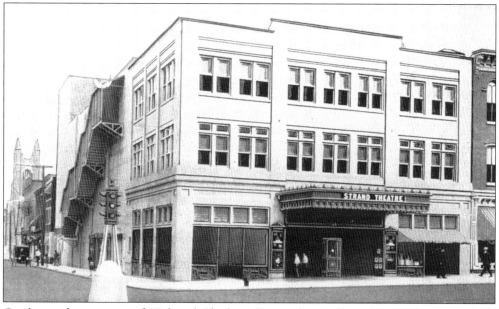

On the northeast corner of High and Charlotte Streets, the Art Deco Strand Theater was built in the 1920s. This theater showed perhaps the more refined films of its times, while the Hippodrome hosted the Saturday matinees of oaters, or westerns. The vacant store to its left housed a restaurant in the 1950s and 1960s.

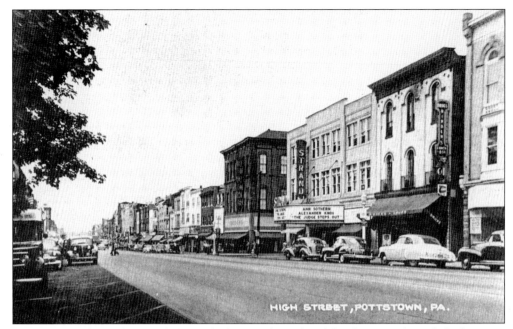

A 1940s card shows the Bressler's men's shop to the right of the theater and Binder's drugstore just to the right of Bressler's. On the other side of the theater, to the west, the old YMCA building is now Block's furniture store, and it remains a furniture store today, occupying both north corners.

A pre-1961 card illustrates some of the previous areas seen in more modern times. The reverse of this card says that the Pottstown business section contained more than 200 retail outlets.

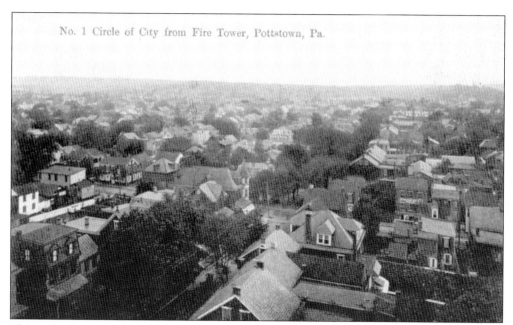

No. 1 Circle of City from Fire Tower, Pottstown, Pa.

This is the first in a series of six views of the town taken from atop the Phillies Fire Company tower at Chestnut and Penn Streets. This view is looking northeasterly toward Charlotte Street. The house in the center with a turret is at the northwest corner of Charlotte and Evans Streets.

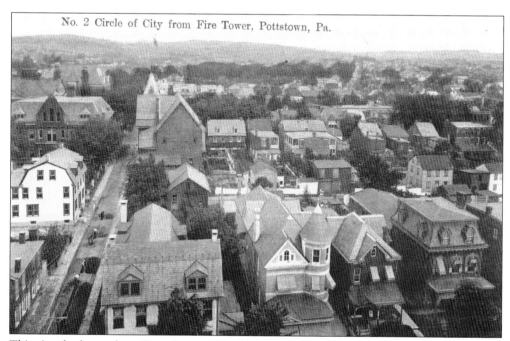

No. 2 Circle of City from Fire Tower, Pottstown, Pa.

This view looks north on Penn Street. The old Pottstown High School is seen beyond the white building on the left.

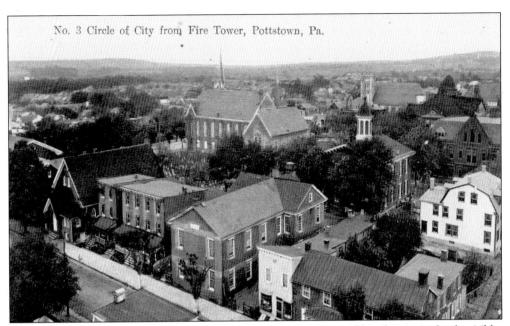

This view looks west up Chestnut Street. The Emmanuel Lutheran Church spire is clearly visible. The parsonage for Zion's Reformed Church is in the left center of the picture.

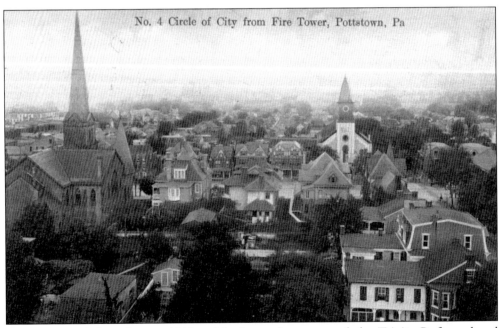

This series card dates from *c.* 1910 and looks southwest toward the Trinity Reformed and Transfiguration Lutheran Churches.

32

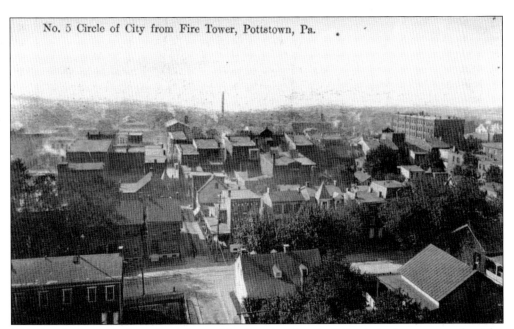

No. 5 Circle of City from Fire Tower, Pottstown, Pa.

This view looks south down Penn Street. The Security Trust building is the large one on the right. Note the smog from the heavy industry to the south, or rear, of both of these pictures.

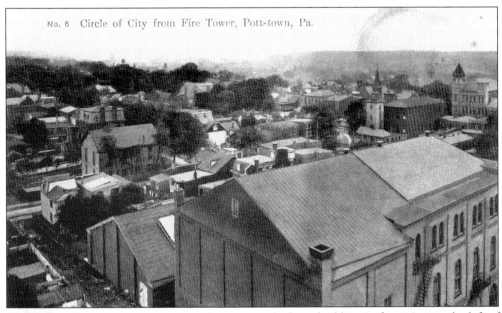

No. 6 Circle of City from Fire Tower, Pottstown, Pa.

Looking to the southeast, we can see the armory, the large building in front. Just to the left of the armory is the Baptist meetinghouse at King and Charlotte Streets. The Auditorium building is in the upper right.

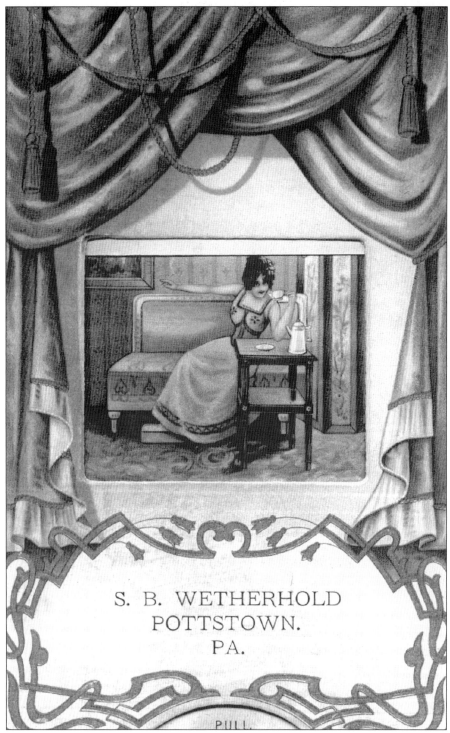

S. B. WETHERHOLD
POTTSTOWN.
PA.

PULL

This mechanical advertising card was actually a mailer printed before 1906 in Germany. It is quite clever. The refined young lady on this page prepares afternoon tea. However, when the tab at the bottom of the card is pulled, she transforms into the brazen lady of the night, with a liquor

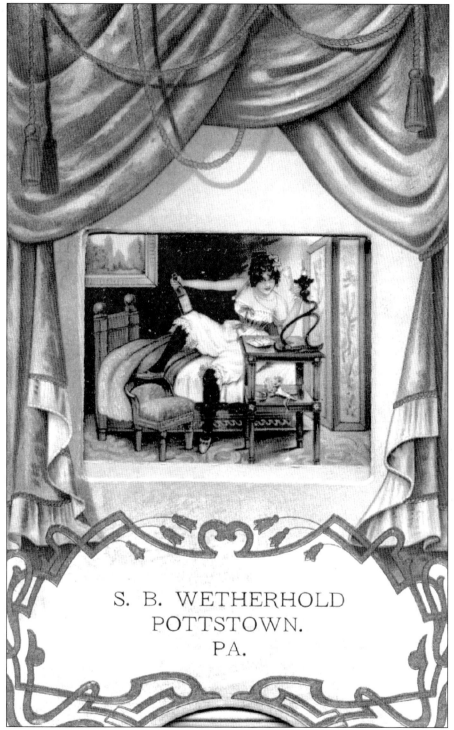

S. B. WETHERHOLD
POTTSTOWN.
PA.

bottle and scanty clothing. It seems a bit on the risqué side for the times. Who said all the Victorians were straight-laced? Wetherold's, located on King Street, was a purveyor of liquor in the early 1900s.

Many beautiful greeting postcards were sent from Pottstown *c.* 1900.

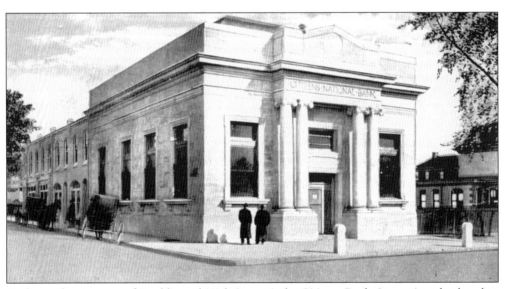

At the northeast corner of Franklin and High Streets is the Citizens Bank. It remains a bank today.

This was the gracious old home of the Pottstown Public Library for many years. The Century Club was instrumental in purchasing it from the Casselberry family in 1920. It was used until *c.* 1970, when the library was able to expand its operations into what was the old post office building, about one block farther east on High Street. The building stood next to the Citizens Bank and is now the site of a parking lot. The reading room on the enclosed porch made studying a delight, or at least a bit more enjoyable.

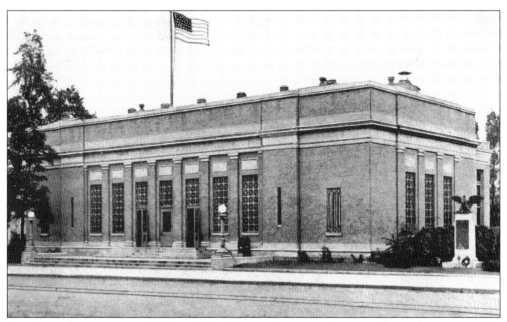

On the southeast corner of High and Washington Streets are the post office and war memorial. This 1930s building has since become the Pottstown Public Library.

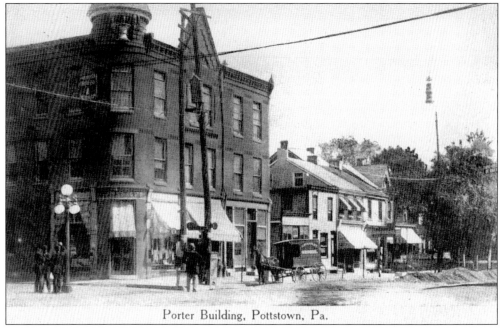

Porter Building, Pottstown, Pa.

At the northeast corner of High and Washington Streets was the Porter Building with its pharmacy. The C. W. Markley Produce wagon seems to be making a delivery. The postmark on this card is 1913. Later, the pharmacy became Cannings drugstore, which in turn moved from farther west on High Street to make way for the Robert P. Smith Towers.

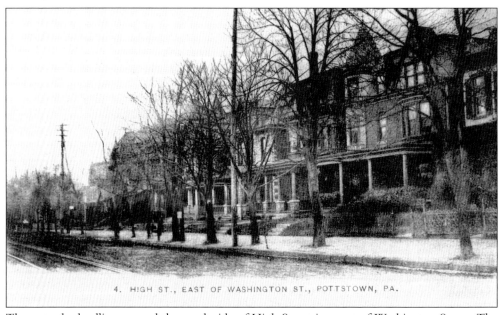

4. HIGH ST., EAST OF WASHINGTON ST., POTTSTOWN, PA.

These stately dwellings graced the south side of High Street just east of Washington Street. The Pottstown Historical Society now has its home in this block.

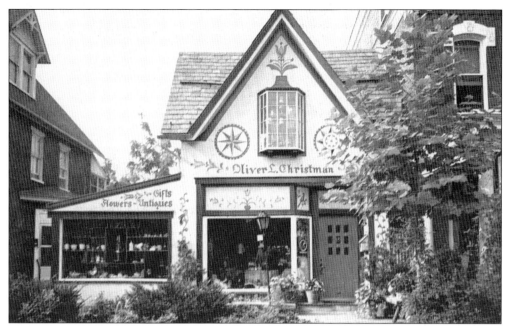

This is the building that now houses the Pottstown Historical Society. In the mid-20th century, it was the delightful shop of Oliver Lewis Christman, a florist and antique dealer.

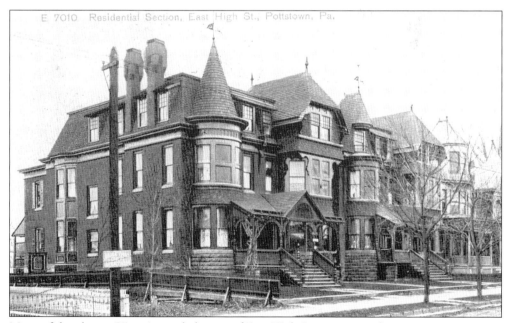

More of the elegant Victorian-style homes of East High Street are seen here.

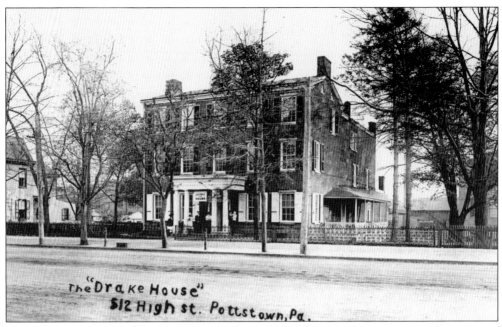

The Drake House was formerly a boardinghouse located on High Street somewhere east of Adams Street.

We are looking east on High Street toward the site of the current post office. The white Italianate-style home is at the corner of High and Madison Streets.

This is a closeup of the same building. It remains today with some alterations to the exterior but is recognizable.

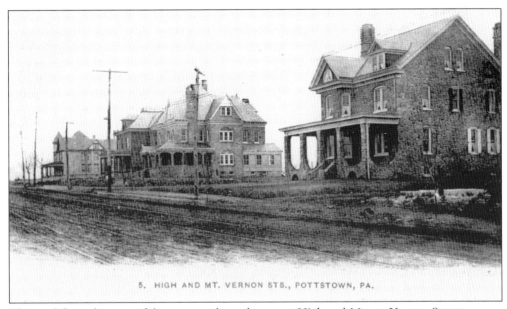

5. HIGH AND MT. VERNON STS., POTTSTOWN, PA.

This card from the turn of the century shows homes at High and Mount Vernon Streets.

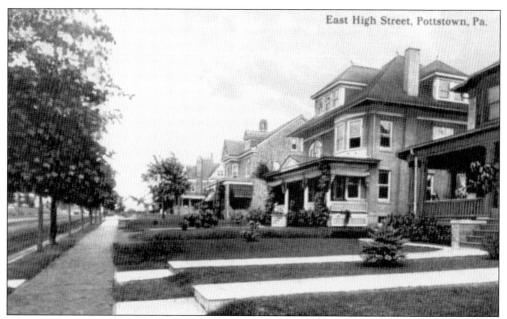

East High Street, Pottstown, Pa.

Another streetscape of Pottstown's East End is seen here. Many of these homes, with alterations, still remain.

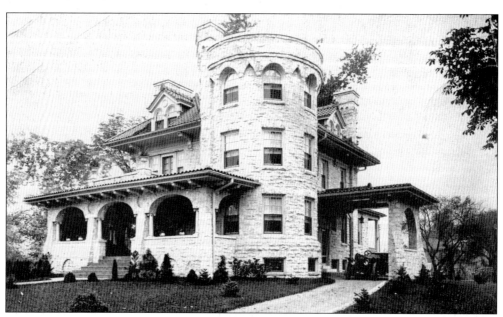

A very elegant home in the east end on High Street is seen here.

Two
TRANSPORTATION
AND INDUSTRY

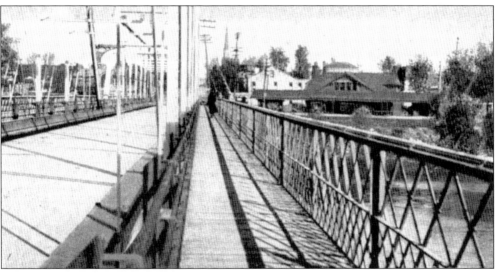

Pottstown did not grow up by itself on the Schuylkill River. The river was the key to the movement of goods and materials, especially with the advent of the Schuylkill Canal _c._ 1820. This canal ran from Philadelphia to Pottsville on the south, or Coventry, side of the Schuylkill River. When the railroads took over the transportation of goods, the growth of the area was explosive.

Pictured is the Hanover Street Bridge, which leads directly from Pottstown to South Pottstown in North Coventry. Prior to man-made forms of transportation spanning the Schuylkill River, there were fords to and from Coventry in Chester County. There was one at the foot of Laurelwood and River Roads in the now Pottstown Landing area of North Coventry and one at Parker's Ford in present-day East Coventry. After the Battle of Brandywine and the Battle of the Clouds, Washington sent scouts to check the condition of the ford at the end of the trail we now know as Laurelwood Road. The water there was too high because of the heavy rains, but the scouts found that Parker's Ford was suitable to move the Revolutionary troops into Montgomery County.

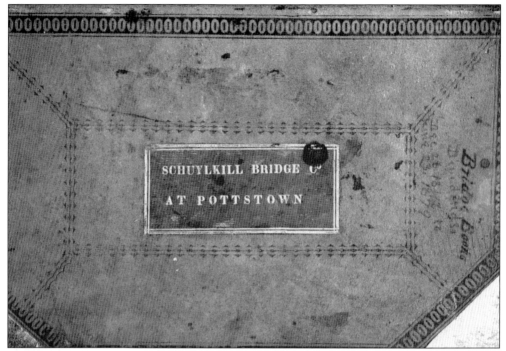

There were covered bridges at Douglassville in Berks County, Hanover Street, Madison (now Kenilworth), and Parkerford. There was a covered bridge over the Manatawny Creek as well. Most were toll bridges. The Hanover Street Bridge was completed in 1820. By 1828, the shareholders were being paid dividends. There are at least two dividend books for the bridge from 1828 to 1879 listing the shareholders, their dividends, and their signatures when the funds were actually received by them. One of them is shown above, and the signatures inside read like a *Who's Who* of the area. This was probably the most important span in Pottstown for the farmers getting their crops to market and being able to buy the goods and services they required.

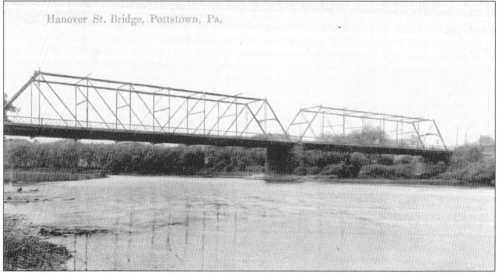

This bridge was a replacement for the covered bridge at Hanover Street. It was replaced after Hurricane Agnes in 1972 caused irreparable damage.

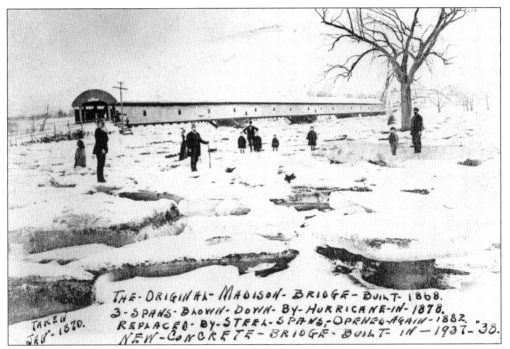

The Madison Bridge spanned the Schuylkill River at the east end of Pottstown, linking it to Madison (now Kenilworth) in North Coventry Township in Chester County. From this 1870 photograph, it appears to be a very long covered bridge. The bridge was built in 1868, lost three spans in a hurricane in 1878, and was rebuilt partially with steel in 1882.

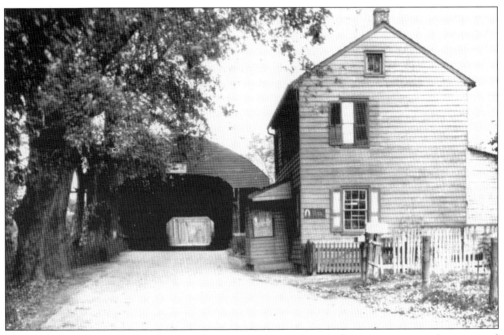

This is the tollhouse of the Madison Bridge, which with magnification appears to have several metal spans beyond the wooden section.

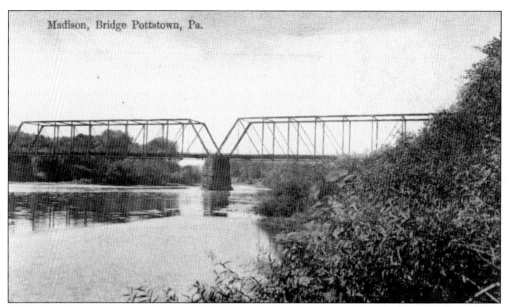

This view shows a more modern steel bridge spanning the river at Kenilworth.

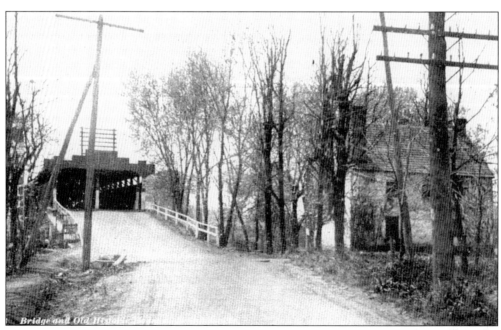

In Douglassville, another covered bridge served the people in crossing the Schuylkill River farther to the west. This picture is from the early 20th century. The home seen in the card is the Mounce Jones house, built in the early 1700s by early Swedish settlers to the area.

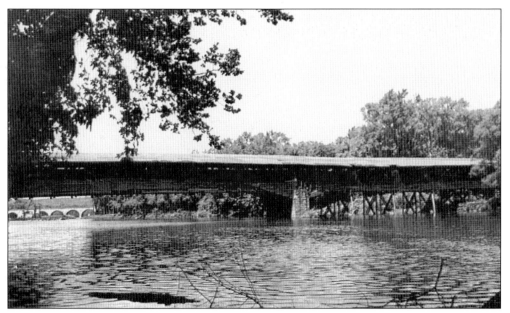

This is how the bridge appeared in the 1950s. Although there was another more modern bridge present, the old covered bridge remained until Hurricane Agnes destroyed it in 1972.

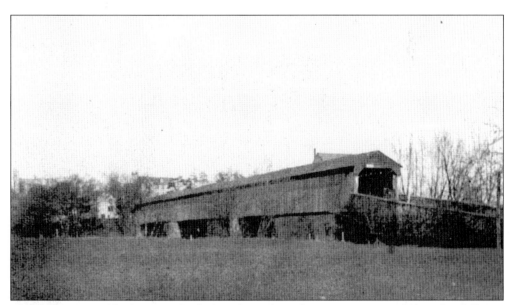

This is the covered bridge at Parkerford in the early 20th century. It crossed the Schuylkill into Linfield, Montgomery County. This is one of many of the cards made by E. D. Miller. Much credit should be given to this gentleman, who preserved area history through these photo postcards.

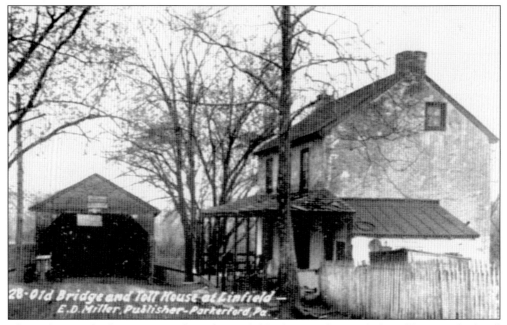

28-Old Bridge and Toll House at Linfield —
E.D. Miller, Publisher-Parkerford, Pa.

This is the same bridge, now seen from the Linfield side, complete with the tollhouse, which still stands today.

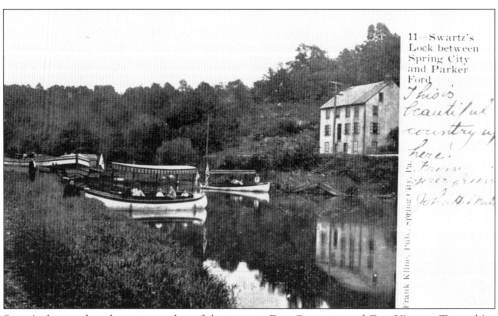

11—Swartz's Lock between Spring City and Parker Ford

Seen is the canal at the eastern edge of the present East Coventry and East Vincent Townships (Chester County) at Swartz's Lock.

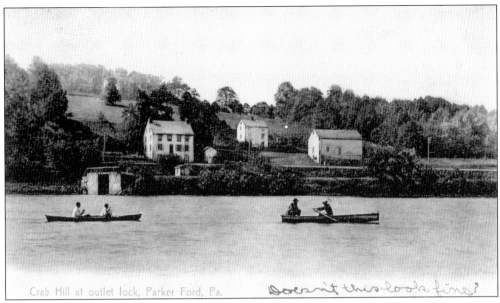

Crab Hill at outlet lock, Parker Ford, Pa. *Doesn't this look fine?*

This is Crab Hill at the outlet lock at Parkerford. The card is postmarked 1911.

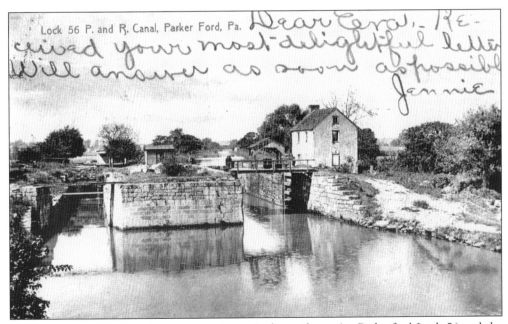

Lock 56 P. and R. Canal, Parker Ford, Pa. *Dear Eva, — Received your most delightful letter. Will answer as soon as possible. Jennie*

This is a wonderful view done prior to 1907. It shows the entire Parkerford Lock 56 and the canal house.

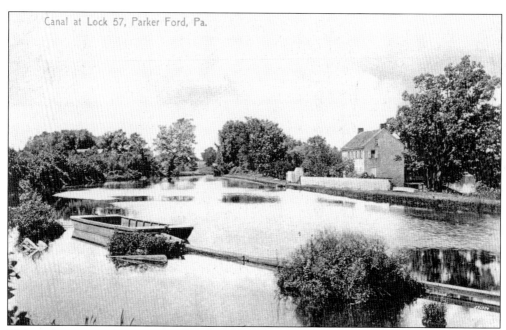

This card is postmarked 1913 and shows Lock 57 at Parkerford.

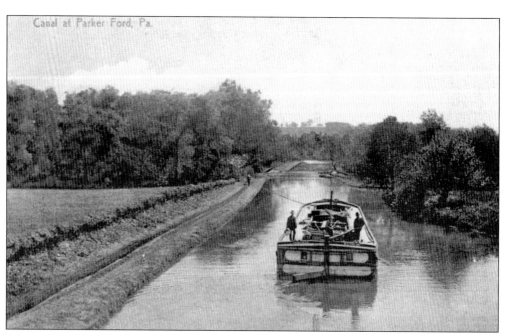

A barge is seen in this picture of the canal at Parkerford. It is a good representation of the typical towpath where normally the mules pulled the barges.

A pre-1907 card of Lock 56 at Parkerford is shown here.

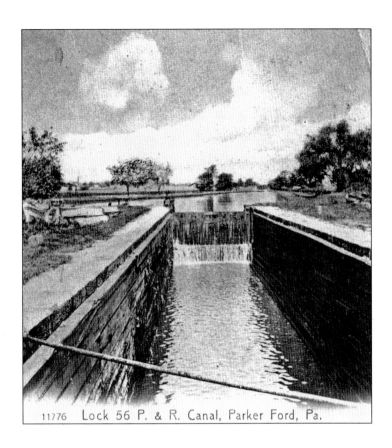

11776 Lock 56 P. & R. Canal, Parker Ford, Pa.

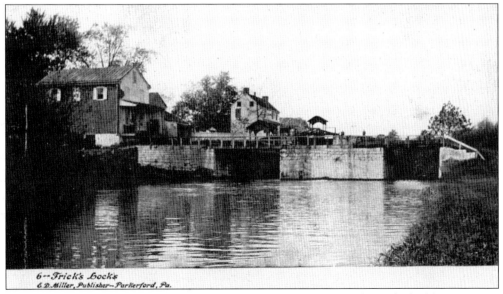

6 -- Frick's Locks
G.D.Miller, Publisher -- Parkerford, Pa.

This is Frick's Lock farther west in what is now East Coventry Township. The buildings are now owned by the nuclear power plant across the river, but there is a movement by historically minded area residents to restore the old village.

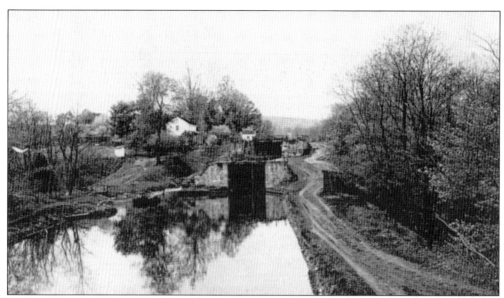

These are the Laurel Locks in North Coventry. Nearby, the village of Pottstown Landing was directly linked to the canal and, in 2001, was placed on the National Register of Historic Places. The industry of the village supported the canal in every way, from boatbuilding and boat repair to care of the tow animals. While other villages grew with the canal's traffic, they had existed before the canal came into being. Pottstown Landing was the first village created solely to service the canal.

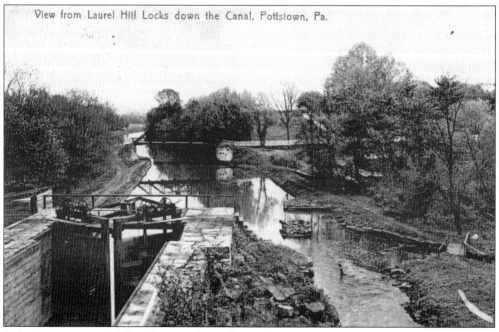

This view appears to be looking east down the canal.

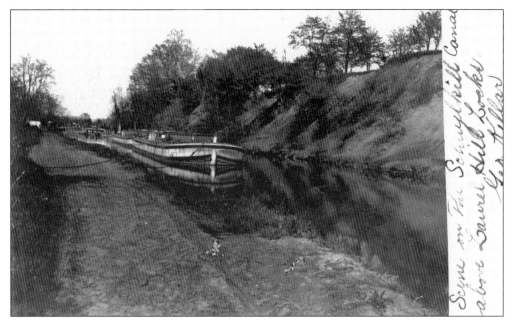

This card shows the lineup of barges on the canal. The canal was in little use after 1920. In the early 1900s, instead of transporting coal, lumber, and other products, it became a recreational place. Sunday school picnics and other outings were remembered by Henry Wanger from his youth. After a short ride on the canal, the picnics would be held at some scenic spot along the Schuylkill.

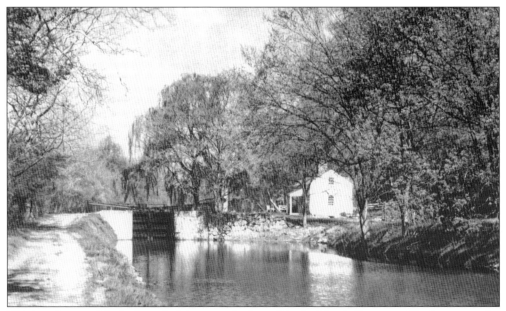

This is a picture of the lock tender's house at the Laurel Locks, North Coventry. The home remains today and is part of the Laurel Locks Farm complex. This very early picture gives a wonderful view of the towpath. At first, the railroads competed with the canal for hauling coal from the Pottsville area coal fields to Philadelphia, but the trade shifted to the railroads as they became more accessible and reliable. When the canal was abandoned, the Pennsylvania Department of Transportation appropriated the canal bed for the Route 422 bypass in the North Coventry area.

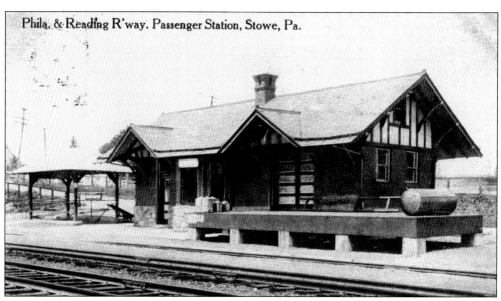

This railroad depot served the Pennsylvania and the Reading Railroad with a stop in Stowe, just west of Pottstown. The Pottstown and Stowe stations are barely a mile apart. It is doubtful the engine got a full head of steam in that short distance. This fairly rare postcard is from 1913 according to the postmark. The station has had many uses over the years. About 20 years ago, it was a fine restaurant for a short time. Train memorabilia decorated its walls at that time, making the Depot a very interesting place to dine.

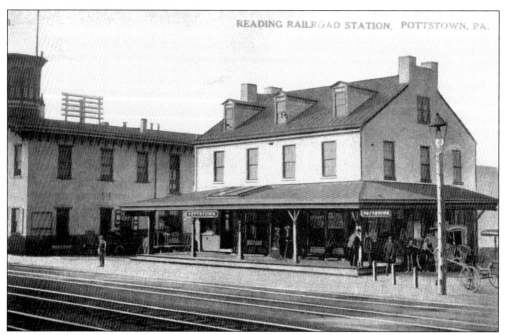

In 1838, service was completed on the Reading Railroad between Reading and Philadelphia. This completion vastly increased the population of Pottstown by 140 percent between the years 1840 and 1850, bringing it to a bustling 1,664. This is an early picture of the Reading Railroad station in Pottstown.

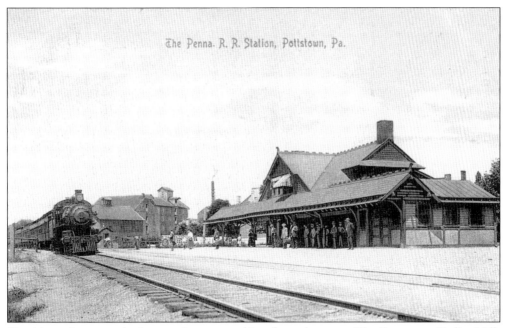

The Penna. R. R. Station, Pottstown, Pa.

On this card we see the locomotive approaching from the west. The Pottstown Roller Mills building is visible between the train and the station.

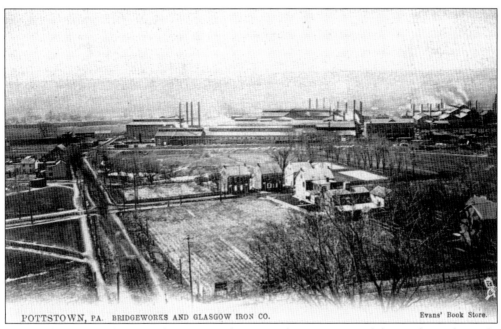

POTTSTOWN, PA. BRIDGEWORKS AND GLASGOW IRON CO. Evans' Book Store.

These railroads served many industries over the years. This pre-1907 card depicts the Bridgeworks and the Glasgow Iron Company.

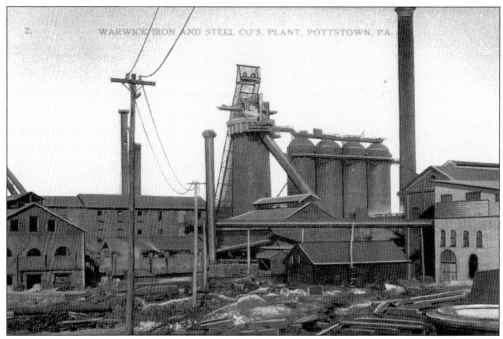

WARWICK IRON AND STEEL CO'S. PLANT, POTTSTOWN, PA.

Pictured here is the Warwick Iron and Steel Company plant. Many years ago, an elderly acquaintance told of ice-skating on the old canal in North Coventry. When Warwick dumped its slag at a certain hour in the evening and lit up the sky, the skaters knew it was time to head home.

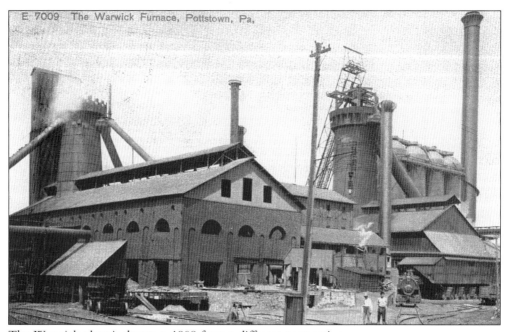

E 7009 The Warwick Furnace, Pottstown, Pa,

The Warwick plant is shown *c.* 1908 from a different perspective.

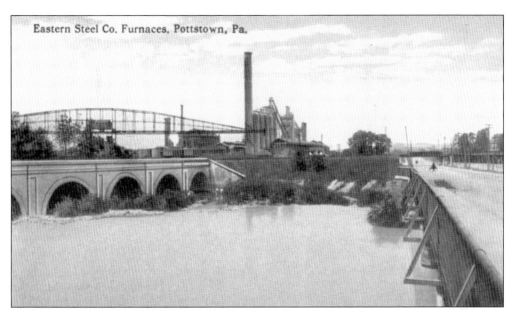

Eastern Steel Co. Furnaces, Pottstown, Pa.

The Eastern Steel furnaces are seen here. Pottsgrove Manor is on the right, and the carriage is crossing the Manatawny on the High Street Bridge. The arched bridge and the girder bridge are railroad bridges.

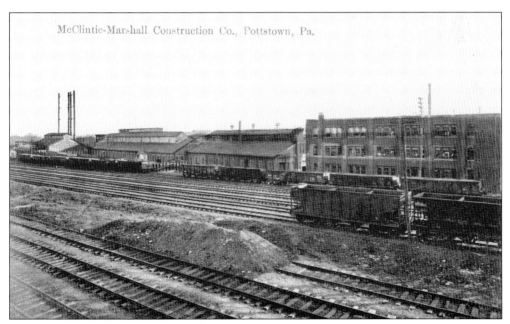

McClintic-Marshall Construction Co., Pottstown, Pa.

McClintic–Marshall was the forerunner of the Bethlehem Steel Company in Pottstown.

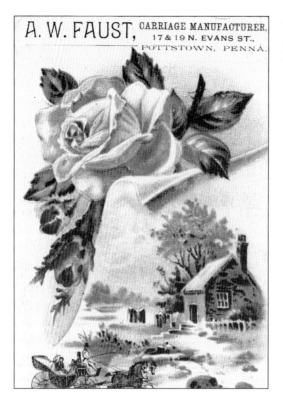

This card was an advertisement for a carriage manufacturer by the name of Faust, located on Evans Street.

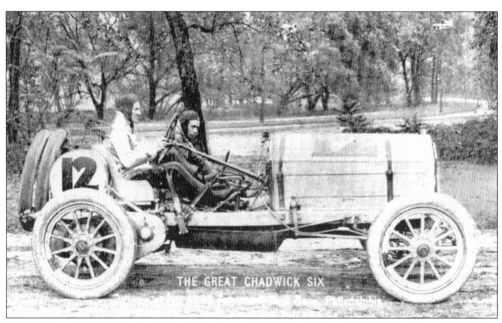

THE GREAT CHADWICK SIX

Chadwick automobiles were made in Pottstown in the beginning of the 20th century. This view shows the great Chadwick 6 racer, the winner of the Fairmount Park race in Philadelphia. The company drivers took their creations out into the open countryside, looking for good hills to test-drive their vehicles.

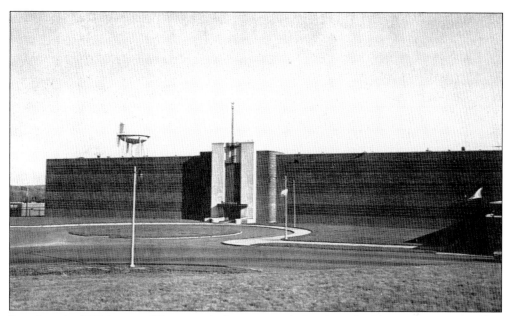

Seen here in 1960 is one of Pottstown's former great industries—the Firestone Tire & Rubber Company. Its sojourn in Pottstown provided jobs and now retirement benefits for many people.

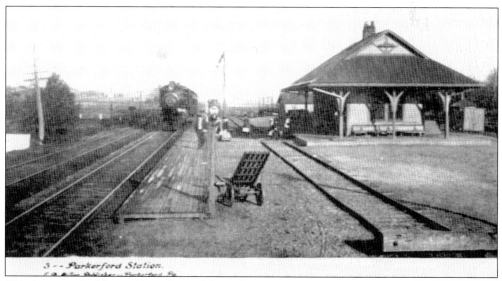

This is a wonderful pre-1907 view of the railroad station at Parkerford in East Coventry. The station is long gone.

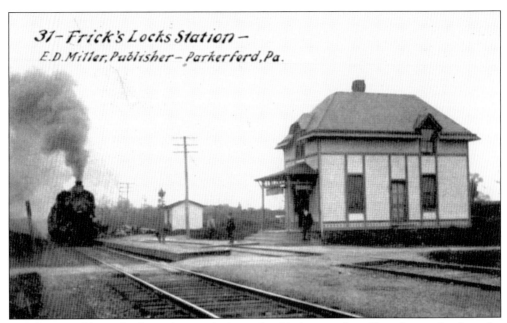

Recalling Frick's Locks from the canal views, in this image, the village has updated to the railroad, and the station accommodating this mode of travel is seen.

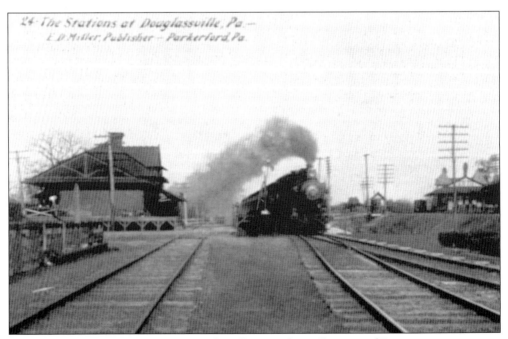

Seen here is the railroad station at Douglassville just a few miles west of Pottstown.

Three
AREA SCHOOLS

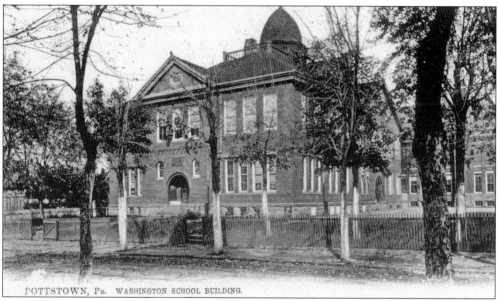

POTTSTOWN, Pa. WASHINGTON SCHOOL BUILDING.

High school education was served by one school in a township or by an agreement to pay Pottstown or a nearby school tuition for its students. This tuition sharing allowed students to attend the school of their choice if it specialized in the courses they wished to pursue. This continued until the 1950s, when the school jointures of the various townships created the large high schools and middle schools we have today.

Above is a pre-1907 view of Pottstown High School standing where the Pottstown administration buildings now stand on Beech Street. At one time, the boys and girls were separated at the high school age.

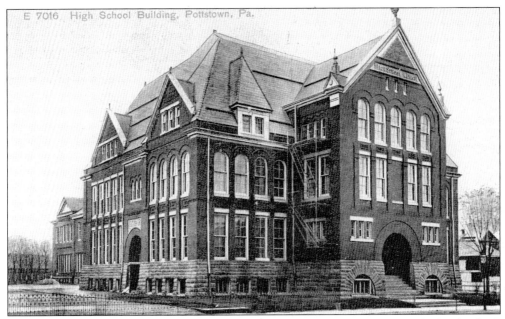

Pottstown High School was built in 1892, combining both the boys' and girls' high schools. A fire in 1933 destroyed this building.

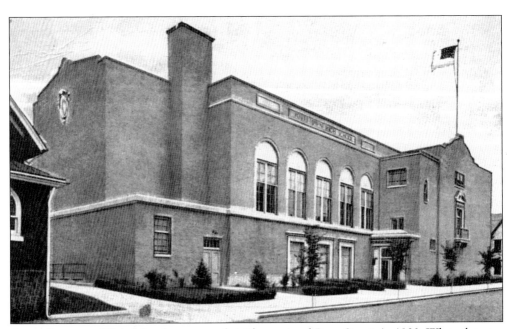

A new Pottstown High School was erected at Chestnut and Penn Streets in 1923. When the new high school was built, this facility became a middle school for a short period of time. It has since been razed for a parking lot.

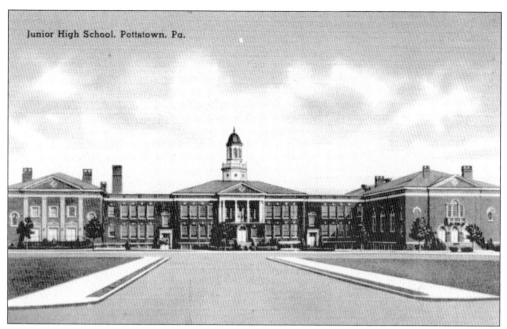

The beautiful Pottstown Junior High School was built in 1932 and still functions today with recent additions and modifications.

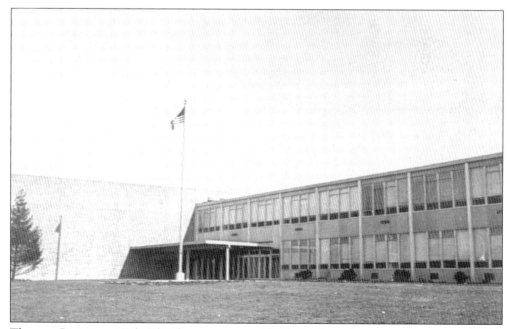

The new Pottstown High School was constructed in the 1960s and was recently renovated. This photograph was taken by Gene Orlando in the 1960s.

This is the former Grant Elementary School, at South Keim and South Streets. It still stands and is home to the Eagles fraternal association.

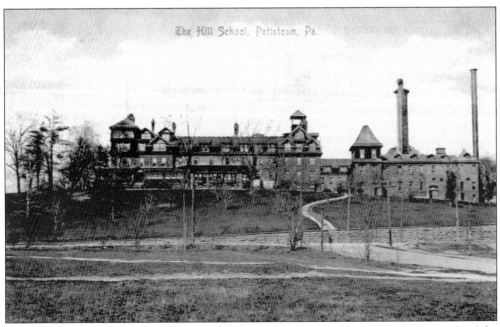

Pottstown is fortunate to have in its midst the Hill School, a prestigious preparatory school for young men and women of high school age. Until a few years ago, it catered only to male students and has produced some of the greats of our nation in every walk of life, from politicians to authors to actors to business tycoons. This is an early card showing the complex at that time.

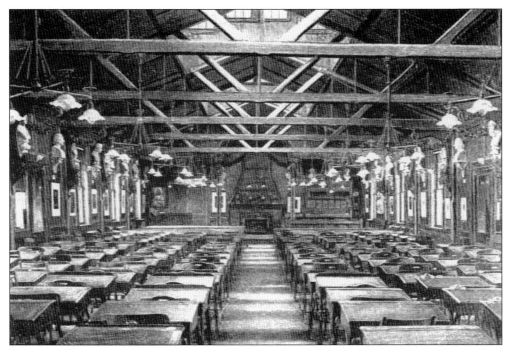

This is a fairly rare card showing a pre-1907 classroom at the Hill School. Note the illumination. They are probably electrified gas lamps.

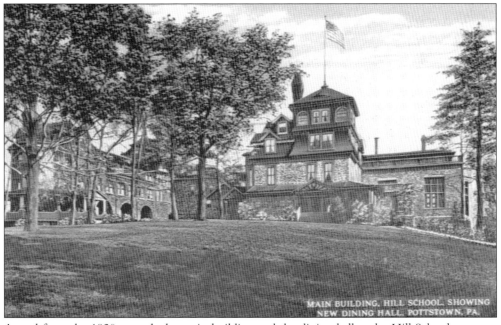

A card from the 1920s reveals the main building and the dining hall at the Hill School.

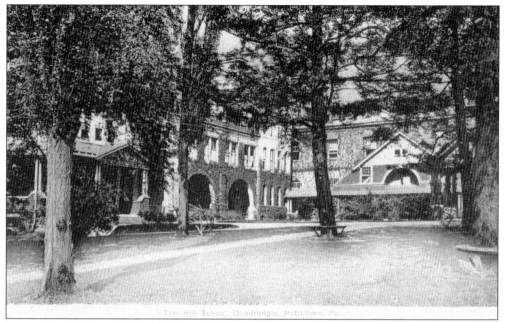

This is a lovely view of the quad in the 1920s. The Hill School was begun in 1851 by Matthew Meigs, a Presbyterian minister, the former president of the University of Delaware, a classical scholar, and a former diplomat to Greece.

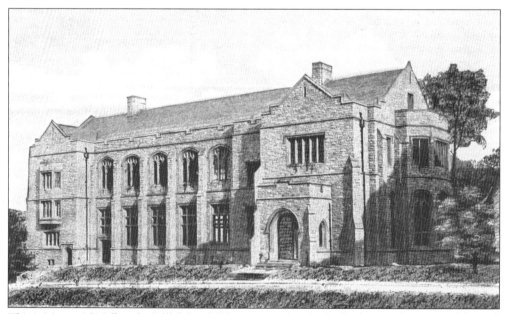

This is Memorial Hall at the Hill School. There was a time in the late 1960s that most of the Hill School masters (teachers) drove small cars. Boys being boys, some students decided a car show either in or at Memorial Hall would be nice, so they physically removed the masters' cars from their parking spots, carried them inside, and then positioned them for a car show.

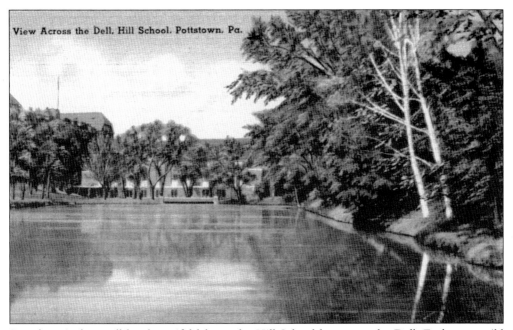

View Across the Dell, Hill School, Pottstown, Pa.

Seen here is the small but beautiful lake at the Hill School known as the Dell. Each year, wild ducks lay their eggs and raise their families along its banks.

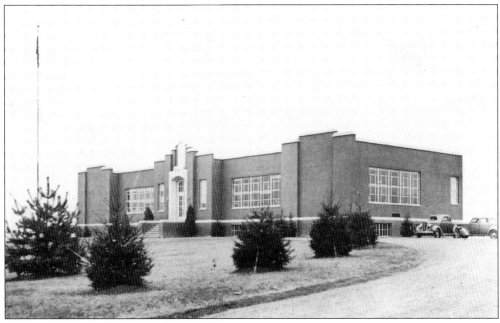

This is a view of the former Lower Pottsgrove Township Elementary School, which has since closed to public school education because of mold.

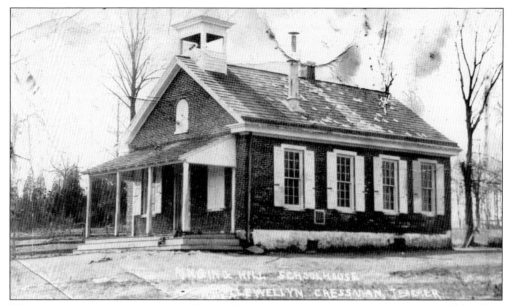

There were many one-room schoolhouses in the tri-county area at the beginning of the 20th century. These schools catered to the needs of the elementary age children up to the eighth grade. For many, an eighth-grade education was sufficient to be successful in their chosen life's careers. Each village had a school, and each neighborhood in town had one as well. Sometimes the schools that have been converted into homes can be seen while driving through the country.

The Ringing Hill Elementary School, seen here, served the Upper Pottsgrove community at the turn of the century. It is certainly different from the modern Ringing Rocks Elementary School serving this area now.

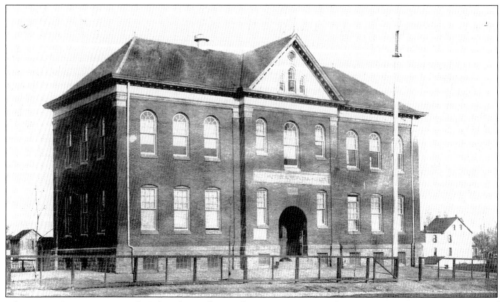

The West Pottsgrove High School was located in Stowe on Berks Street. It served the pupils of the Pottsgrove townships for many years until the new Pottsgrove High School was built.

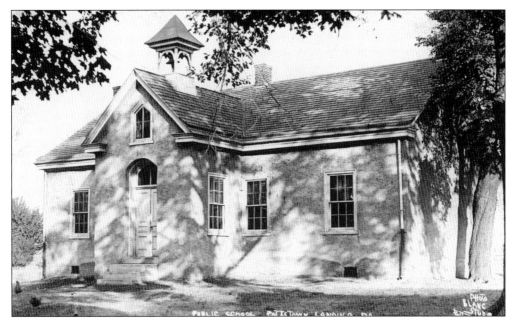

On the other side of the river, in North Coventry Township, the students were being taught in a one-room schoolhouse in Pottstown Landing. It is reported that the school had existed since 1859 and that the ground was given to the school by George Wanger in 1868. This is the school as it appeared *c.* 1900.

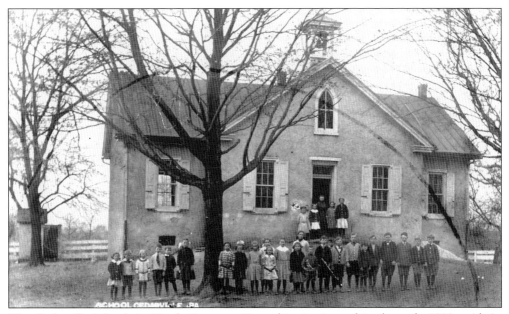

The Cedarville School, in North Coventry Township, is pictured in the early 1900s with its pupils. The school is now a very elegant private residence gracing the village of Cedarville.

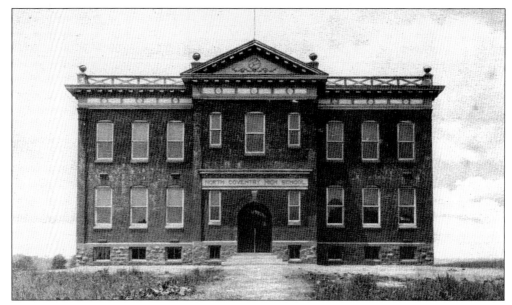

North Coventry High School is seen here in a very early view. It merged with the Owen J. Roberts School District in the late 1950s. After the construction of the new high school, this building was used for the fourth and fifth grades of North Coventry Elementary School.

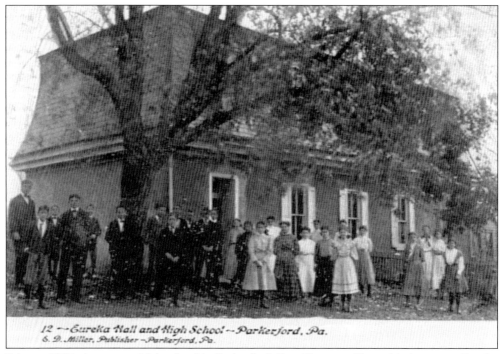

12 — Eureka Hall and High School — Parkerford, Pa.
S. D. Miller, Publisher — Parkerford, Pa.

Prior to 1907, there was a high school in Parkerford, East Coventry Township known as Eureka Hall and High School.

Four

AREA CHURCHES

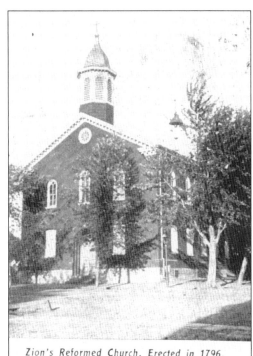

Zion's Reformed Church, Erected in 1796,
Pottstown, Pa.

Many of the early families of the greater Pottstown area emigrated from Europe in search of the religious freedom that William Penn's colony promised. All faiths are represented in the area.

Zion Reformed Church (United Church of Christ), or the "Old Brick Church," on Hanover Street is the earliest remaining church building in Pottstown. It was built in 1796 by a congregation formed in 1769 who wished to conduct their services in German, which they did for many years. At least five congregations of various denominations worshiped at the church before moving on to establish church buildings of their own.

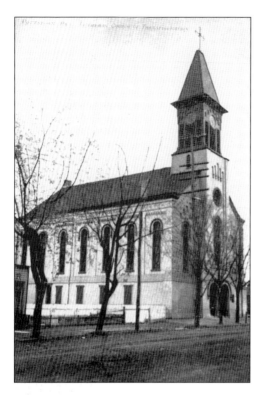

This early view reveals the Transfiguration Lutheran Church, located across the street from the Old Brick Church. The congregation was formed in 1834, and the church was erected in 1859. The original steeple was destroyed and replaced by the clock tower that remains today. Originally, it was known as the English Lutheran Church of the Transfiguration.

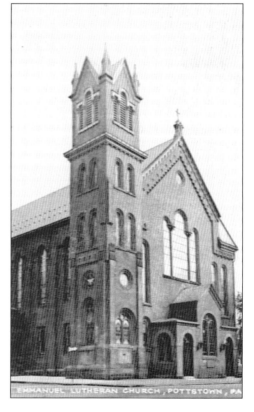

In the same block as the previous churches we have seen is the Emmanuel Lutheran Church, which has the largest Protestant congregation in Pottstown. This is the front on Hanover Street much as it appears today.

Originally, the steeple looked much like the one in this 1909 postcard. The first steeple was destroyed in 1878 during a very bad storm, as was the steeple atop the Transfiguration Lutheran Church.

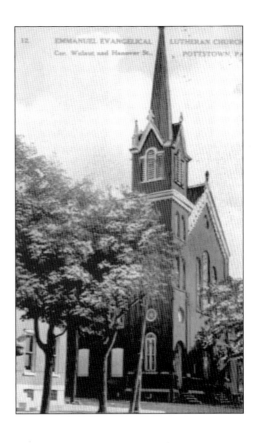

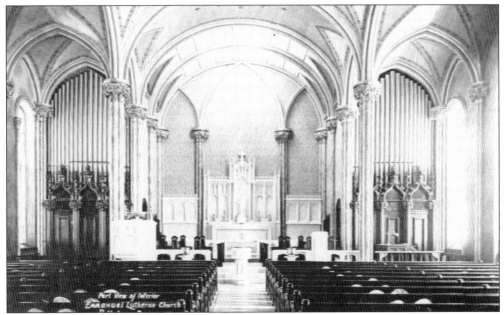

A very early interior view of Emmanuel Lutheran Church is seen here.

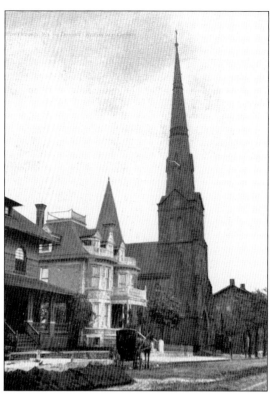

This early card depicts the Trinity Reformed Church (United Church of Christ), at Hanover and King Streets. The church was constructed in 1868.

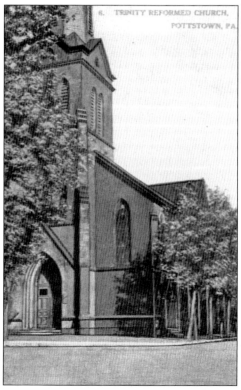

The front of the Trinity Reformed Church, on Hanover Street, is seen on this card.

This is a nice view of the St. Aloysius Roman Catholic Church, built in 1891. It replaced an older church built in 1851 at the corner of Hanover and Beech Streets. At that time, the church was located outside the town limits, as Beech Street had not yet opened.

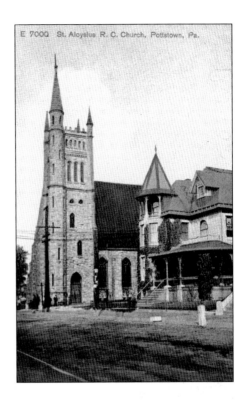

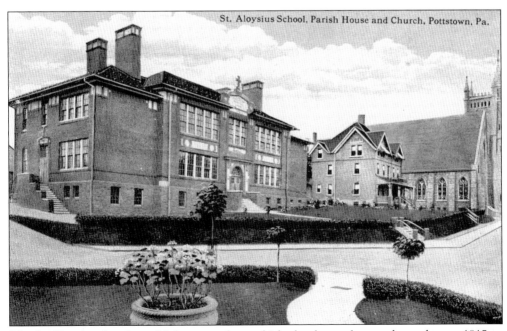

The St. Aloysius church, parish house, and parochial school complex are shown here *c.* 1915.

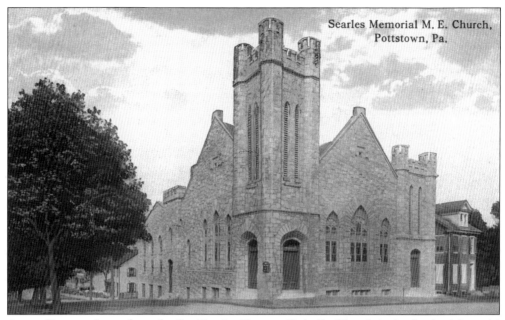

Searles Memorial M. E. Church, Pottstown, Pa.

Across Hanover Street from the St. Aloysius Roman Catholic Church is the Searles Memorial Methodist Church, built in 1912. No longer housing the Searles congregation, it is still home to a church today.

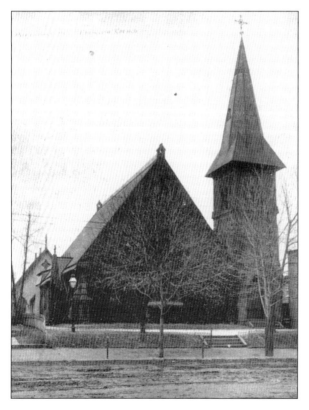

On High Street, now tucked between the old Eagles home and a commercial building, is Christ Episcopal Church. This building with modifications has been used since 1872. The congregation was formed c. 1829 and had various other places of worship. This card is from c. 1908.

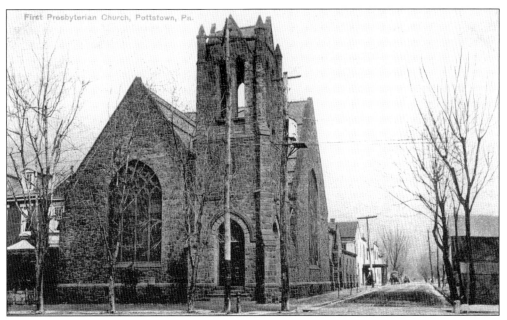

The First Presbyterian congregation was formed in 1848. This was their church home at the corner of High and Evans Streets in the early 1900s. This edifice was razed in the 1960s, when the congregation moved to a new facility on Evans Street in the north end of Pottstown. The area formerly occupied by the church is now a large parking lot.

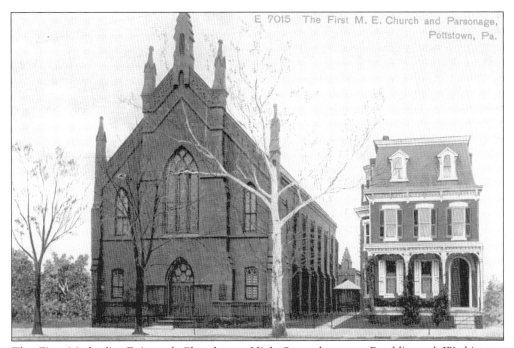

The First Methodist Episcopal Church, on High Street between Franklin and Washington Streets, was built between 1867 and 1871 for a congregation founded in 1836. It is seen here with its lovely parsonage.

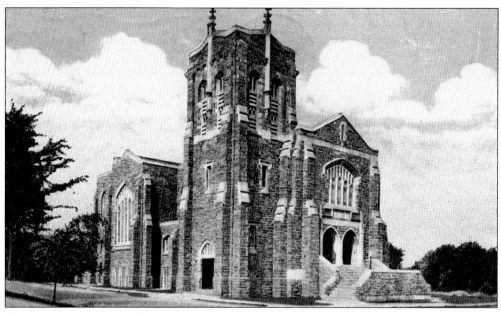

The St. James Lutheran Church is seen here *c.* 1930. It stands at the corner of High and Price Streets and was built in 1916.

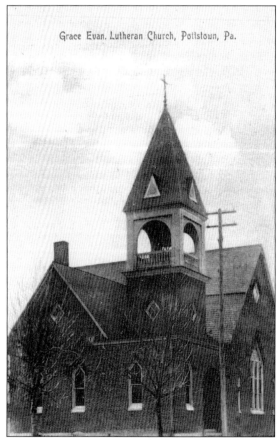

Grace Evan. Lutheran Church, Pottstown, Pa.

This is an early picture of Grace Evangelical Lutheran Church, which stood on West Street and was built in 1897. A new church was constructed on North Charlotte Street in the 1960s.

The First Baptist Church congregation was formed in 1858, and they constructed a meetinghouse at the corner of King and Charlotte Streets. A new church was proposed prior to 1907, and the meetinghouse was demolished. While awaiting completion of their new house of worship, they met just down King Street at the armory building.

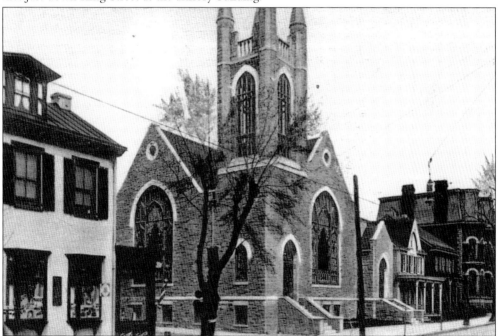

The cornerstone was laid for the church in 1910. Upon the building's completion, the congregation marched from their temporary home to the new facility, singing "Onward, Christian Soldiers." This card shows the new church and parsonage as well as the homes up King Street, where the YWCA now stands. The white building on the left in the picture remains a store.

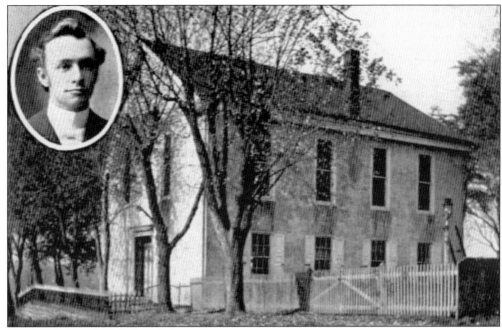

This is a pre-1907 card of the Parkerford Baptist Church, on Baptist Church Road. The congregation was founded in 1852.

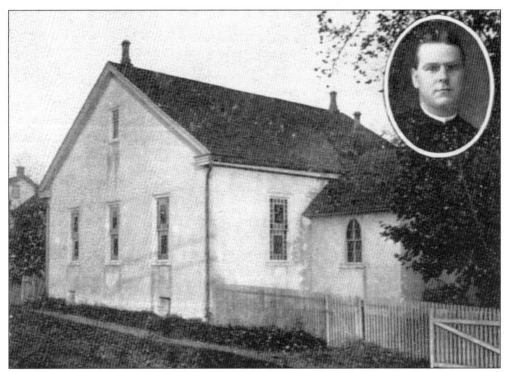

The Parkerford Church of the Brethren, on Bethel Church Road, is seen here. Formed originally as an outreach congregation in 1808, the church building dates from 1848. The postcard is from *c.* 1910.

The Coventry Mennonite meetinghouse and cemetery on Old Schuylkill Road are featured in this card. Some of the area's earliest settlers are buried here. The present building was built *c.* 1798. It is no longer used as a church.

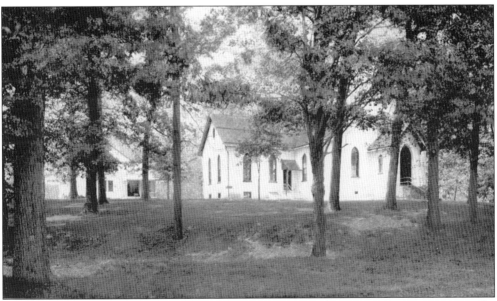

In North Coventry is the lovely Coventry Church of the Brethren, whose congregation is the second-oldest Brethren congregation in the United States. The church was formed by Martin Urner in 1724, and its members met in homes until a log building was constructed in 1772 on the Reverend Urner's property. This was followed by a church of stone in 1817, which was torn down in 1890, and another was built in its place. With some additions and alterations, that church is seen here *c.* 1930.

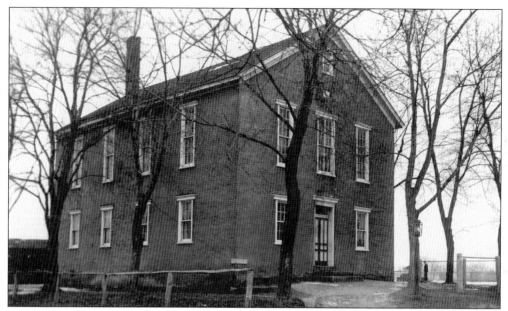

Seen here is the Cedarville United Methodist Church, originally named St. James Methodist Episcopal Church when it was formed as an offshoot of the Temple Methodist Church in 1873. The church has been added to several times since then, and the building seen above is still used as a small fellowship hall and meeting room. The steeple of the new sanctuary can be seen for miles around.

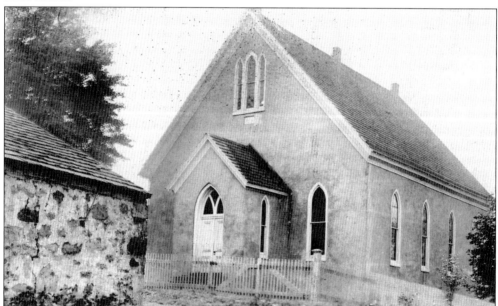

The Shenkel Reformed Church was built in 1839 as a German Reformed church. Today, it is the Shenkel United Church of Christ. The cemetery on the church property has seen burials since the 18th century. This quiet, peaceful country church saw quite an episode of unrest in the early 20th century, when a spouse-sharing religious sect known as the Battle Axes walked unclothed into the church on Sunday morning during services. Because of this sect and their practices, the Shenkel area has been called "Free Love Valley."

Five

CIVIC AND
SERVICE GROUPS

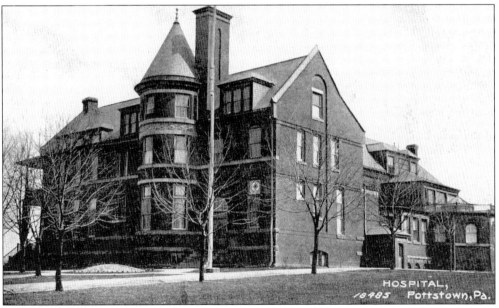

At the beginning of the 20th century, Pottstown was indeed fortunate as a small town to have at least two rather large hospitals serving both the community within and the community surrounding its borders. There were a number of fire companies to assist in times of need, and there were and still are many service clubs, organizations, and fraternal orders in town—some old and some new.

The Pottstown Hospital, pictured *c.* 1906, was begun in 1888 through the effort of the King's Daughters Association. The association itself was formed that same year, and they decided to pursue a benevolent project. This project led to the opening of the hospital in 1892.

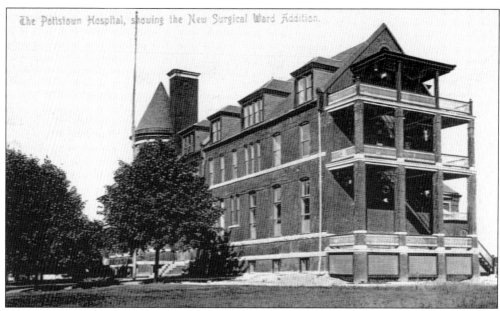

This card of the Pottstown Hospital, on North Charlotte Street, portrays the new surgical ward. The first surgery in the original hospital was done in 1894. The school of nursing opened in 1894 with two enrollees.

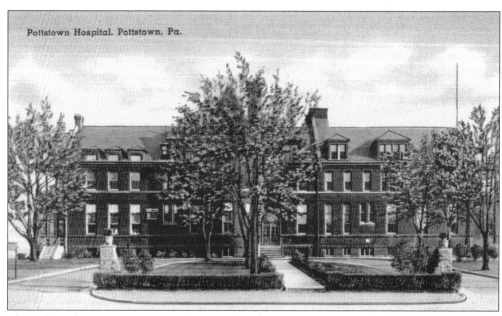

This is how the Pottstown Hospital appeared in the 1930s and 1940s.

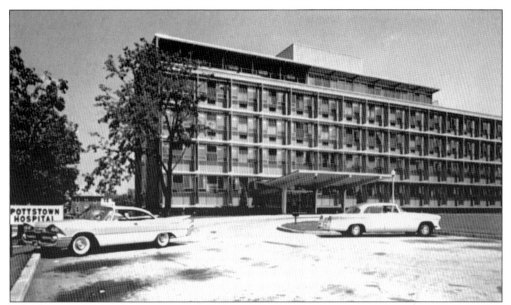

In the 1950s, a very modern entrance addition was placed facing Nightingale Avenue. The hospital was purchased by a long-term care facility after the merger of the Pottstown Hospital and the Pottstown Memorial Hospital formed the Pottstown Memorial Medical Center in the 1970s. This building remains a long-term care facility, but the northern portions of the old hospital, which housed the laboratory, x-ray, and emergency rooms, have been razed.

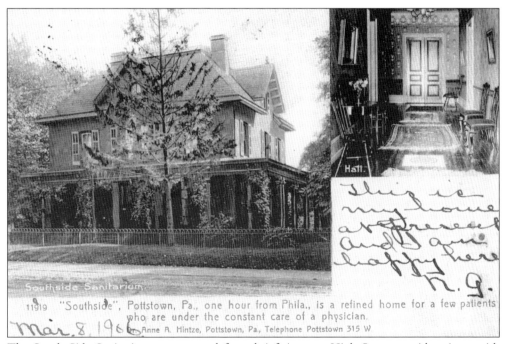

The South Side Sanitarium was opened for a brief time on High Street to aid patients with psychiatric conditions. Here it is shown *c.* 1906. The person sending the card reports to be "happy here." Anna G. Mentzer was the director of the sanitarium, and it was located across from the Hill School.

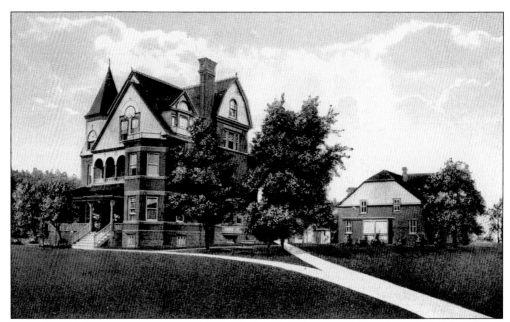

This is a 1920s view of the Pottstown Homeopathic Hospital, opened in June 1914, after the bequest of an early female physician who served the area. The carriage house to the right of the old Eck mansion in which the hospital was created became the nurses' home, where the student nurses and others lived. Its nursing school began *c.* 1916.

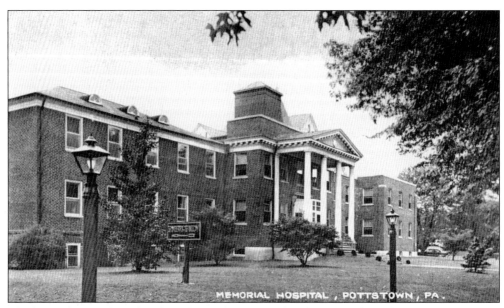

The hospital was enlarged and modernized in 1946 after the close of World War II. A modern emergency room, laboratory, and x-ray department were built. Its name was changed to Pottstown Memorial Hospital.

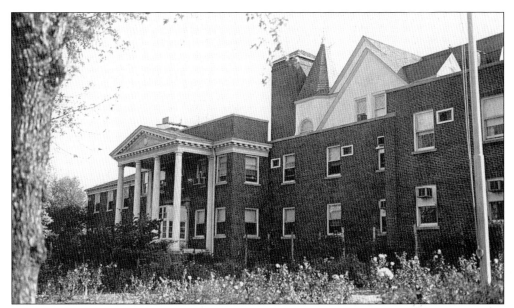

This view shows the hospital as it appears today, although the photograph was taken by Gene Orlando *c.* 1960. It is now an office building, but the turret-top roof of the original mansion is still visible.

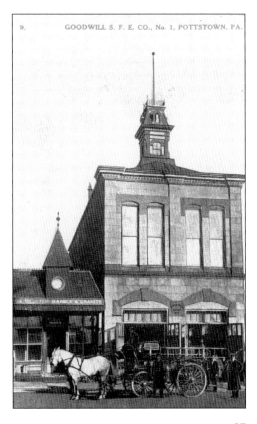

We have several notable fire companies servicing the area, but unfortunately we have few very early cards showing them. Their excellence and importance to Pottstown goes without question. Several major fires ravaged the business district of Pottstown during the 20th century and even in the late 19th century. Without these able-bodied men and their dedication to their volunteer fire companies, many more businesses would have been reduced to ashes. Among the earliest pictures of fire companies is this one of the Goodwill Fire Company's horse-drawn engine in front of their fine old building on the east side of South Hanover Street next to the Reading Railroad tracks. The original building with modifications remains. The marble and granite works next to the fire company is now the news company building. The fire company has a much more modern building on east High Street now.

87

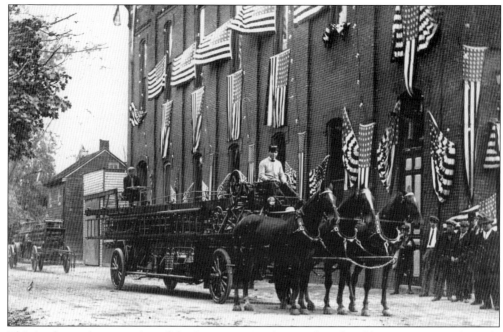

This is a horse-drawn engine of the Pottstown Empire Hook and Ladder Company in the early 20th century. They are probably readying for a Fourth of July celebration. The company is still at the same location—the southeast corner of Franklin and Chestnut Streets.

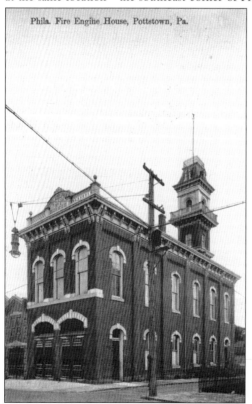

The Philadelphia Steam Fire Engine Company building is seen here in 1910. It is located on Chestnut Street at the southeast corner of Penn Street. The tower on the top afforded the grand aerial views of the area seen in an earlier chapter.

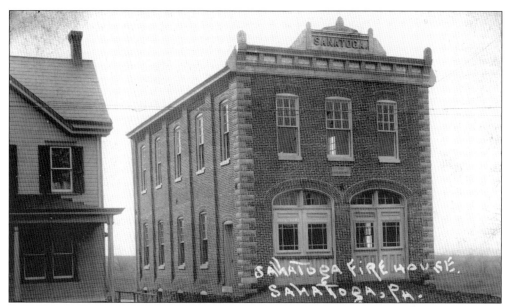

The Sanatoga Fire Company of Lower Pottsgrove, on East High Street, is pictured here *c.* 1910.

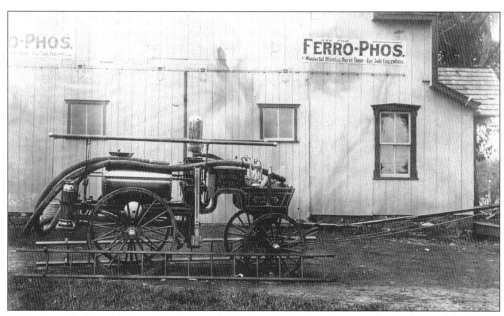

This picture is from 1908 and depicts an old Sanatoga Fire Company engine in front of the Ferro-Phos soda plant.

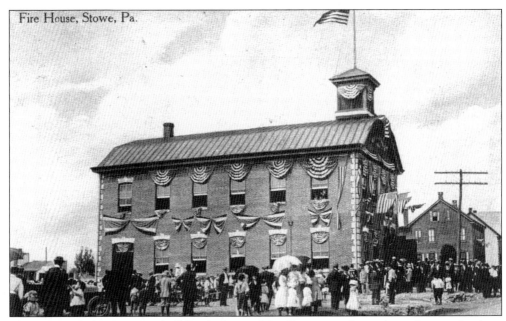

The West End Fire Company building in Stowe, West Pottsgrove, is seen here. Apparently, there is a big celebration of a patriotic holiday by the townsfolk. The card dates from 1918.

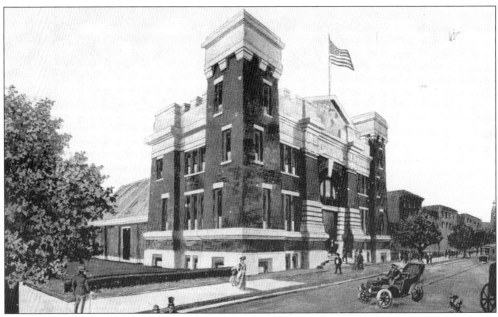

A *c.* 1910 card shows an artist's perspective of the newly constructed Pennsylvania State Armory of Company A of the 6th Regiment of the National Guard. Note the horseless carriages driving over the trolley tracks on King Street. The armory remains today on the north side of King Street between Charlotte and Penn Streets. The armory was built and dedicated in 1909. The National Guard remains a viable part of our community. It originated after the Civil War and, despite regimental name changes, continues in the armory on King Street.

Pottstown's municipal building stood at the northeast corner of King and Penn Streets. The building is still there, but a new facility has been built on High Street for the government offices of the town. The opera house is still standing in this 1930s postcard.

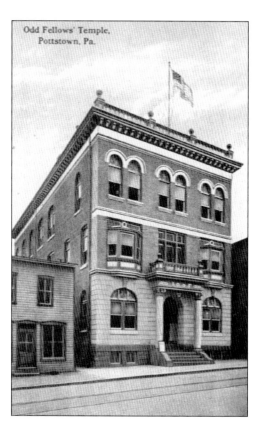

The Odd Fellows temple, merging two lodges, was built c. 1913 on the south side of King Street near Charlotte Street. In later years, the Odd Fellows rented a few of the rooms of their building to Evelyn Shelley, who taught elocution to many of Pottstown's finest. The small building on the left housed a small hardware and tinware shop for many years until both buildings were demolished during urban renewal to make way for a high-rise apartment building. There were and still are many benevolent orders in Pottstown.

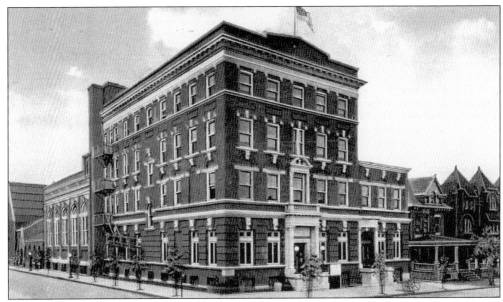

The magnificent new YMCA building was dedicated in 1913 at the southwest corner of King and Evans Streets. Private residences can be seen on King Street to the right of the YMCA, while the back of the old Presbyterian church can be seen on the left, or Evans Street, side of the building. The YMCA was a place for men to find a place to stay as they sought employment during the growing industrial period of Pottstown. These men came from many places without family or friends, but at the YMCA, they could find reasonable facilities to house themselves until wages permitted them to bring their families to town and rent or purchase a home.

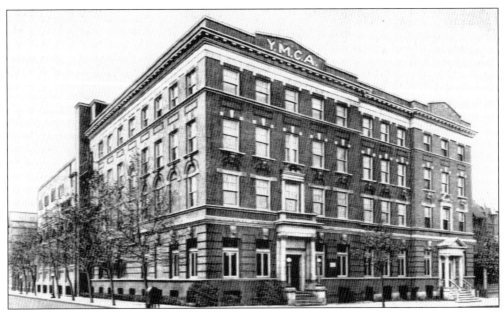

In 1922, the right side of the building was changed by an annex. Later, this annex held Pottstown's only indoor swimming pool, where many of Pottstown's youth first learned to swim. The YMCA was also home to bowling alleys where on many evenings the crashing of the hand-set pins could be heard.

Six
PASTIMES, RECREATION, AND CELEBRATIONS

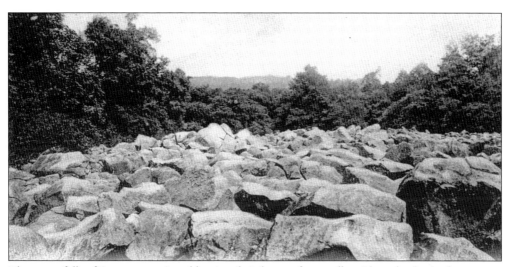

The townsfolk of Pottstown enjoyed leaving their homes for a trolley ride and a day in the country at either Ringing Rocks Park or the Sanatoga Lake Park. This 1905 postcard shows the ice-age rocks deposited in Upper Pottsgrove Township just outside the city limits of Pottstown. If struck with a hammer, the rocks do ring. The summer park, aptly named Ringing Rocks Park, evolved in the late 1800s. The hill on which the rocks are located rises about 500 feet above the surrounding area. The early Pennsylvania Germans referred to it as Klingleberg or Klinglebarrick, terms meaning "ringing rocks." The rocks cover an area of about one and a half acres and are, or were, piled in fascinating shapes. The various tones when hammered depended on the size and density and could sound like anything from anvils to church bells. It is said that all musical notes were covered by the rocks. At one time, a musical octave of these stones, known as a "rockophone," was kept in a pavilion where a certain Mr. Gracey played "Home Sweet Home" for visitors to the park. Over the years, the rocks have been sinking, and caverns once present are long gone. These facts are from a talk given before the Montgomery County Historical Society in 1927 by George F. P. Wanger.

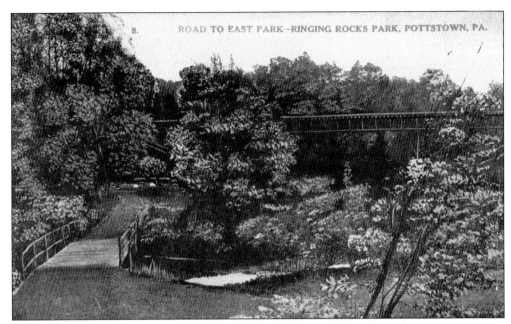

ROAD TO EAST PARK—RINGING ROCKS PARK, POTTSTOWN, PA.

Entitled "The Road to East Park," this card shows the footpath into the park.

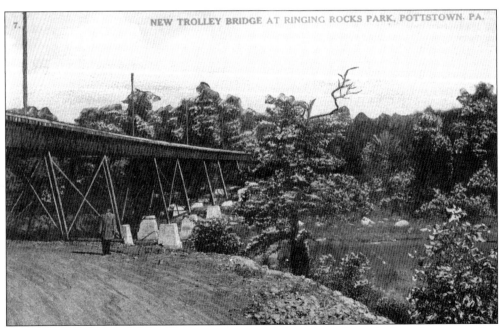

NEW TROLLEY BRIDGE AT RINGING ROCKS PARK, POTTSTOWN, PA.

There were several ways to approach the park, and this view offers a look at the new trolley bridge as a primary means of transportation to the park.

A 1924 card shows the Umbrella Rock at the park.

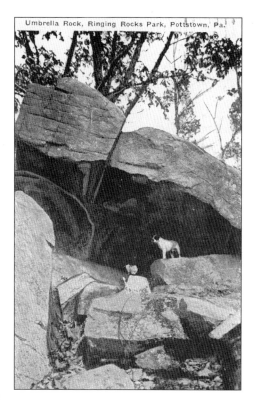

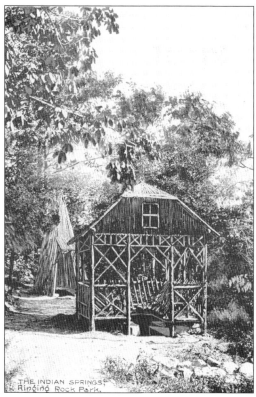

This area was known as the Indian Springs, and it was reported the Lenni Lenape Native Americans came here in pre-Colonial times for fresh water. The card is from *c.* 1907.

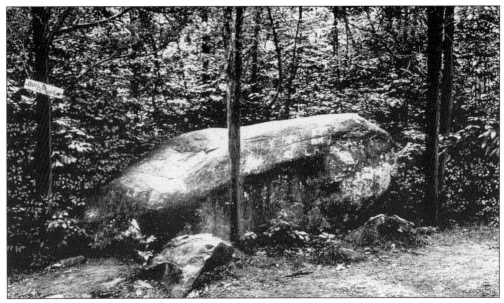

The Bull Frog Rock is seen here. It was surely a favorite of the children upon which to climb.

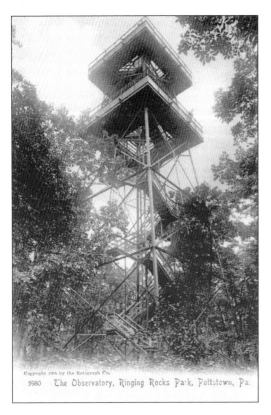

Copyright 1906 by the Rotograph Co.

5980 The Observatory, Ringing Rocks Park, Pottstown, Pa.

A wonderful view could be obtained from climbing this tower at the park.

The Ringing Rocks pavilion is seen here *c.* the late 1920s and has since become the home of the Ringing Rocks Roller Rink.

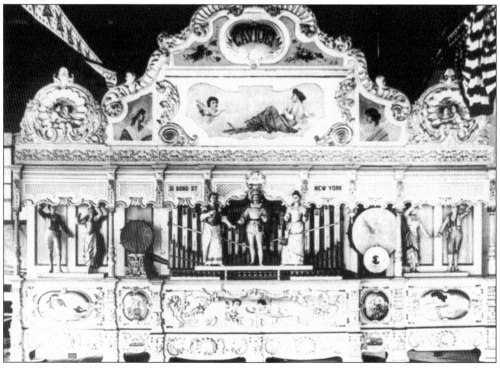

This is a picture of the Cavioli organ from the Ringing Rocks Roller Rink. Its music once made roller-skating grand. At this recreational haven, several generations of young people have enjoyed meeting their friends and making new ones while having some great exercise. Some of those friendships have blossomed into weddings, with at least one marriage conducted at the rink. Although the skates have changed from shoes to in-line, fun still abounds.

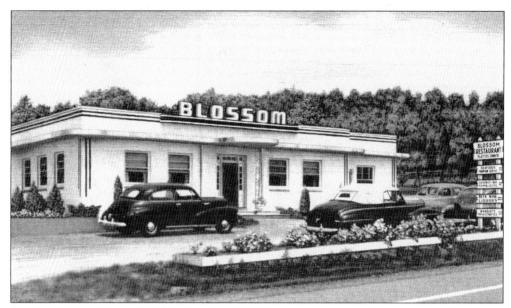

Restaurants grew in popularity during the mid–20th century as people became more affluent and had personal cars to take them to places more quickly than the public transportation of yore. The Blossom Restaurant on North Charlotte Street at Ringing Hill is seen here.

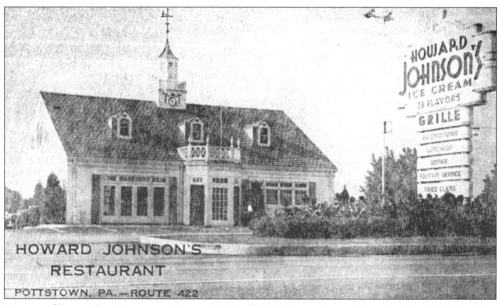

Just east of the residential areas on the south side of High Street, about where the closed food market is today, stood a Howard Johnson's restaurant—a mainstay of culinary delights for many years.

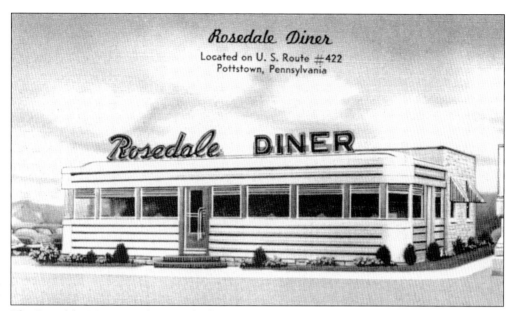

The Rosedale Diner joined Howard Johnson's on the south side of High Street, near where there is a fast-food restaurant today, c. the 1950s. It served the needs of a generation and was then abandoned beside the Schuylkill Road in Chester County.

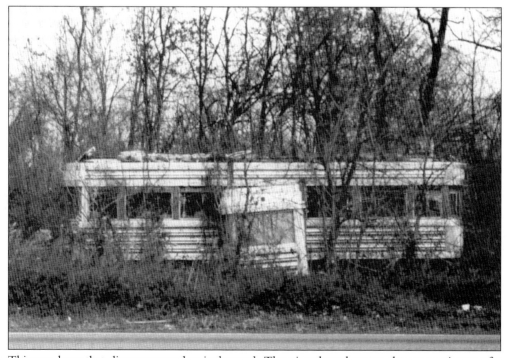

This was how that diner appeared as it decayed. The view later became the cover picture of a 1970s album by Hall and Oates, a local rock and soul group known nationally and internationally.

In town, people have enjoyed recreation on the Manatawny Creek since before the white man came to the area. The name was given to the creek by the Lenni Lenape Native Americans. Fishing has always been a favorite recreation.

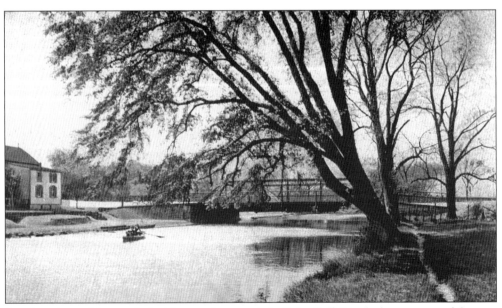

Another view of the creek, looking south toward the Schuylkill River, shows some of the area of the present Memorial Park on the right. The old icehouse on the left is now the site of a restaurant. The card is from the 1910–1920 period.

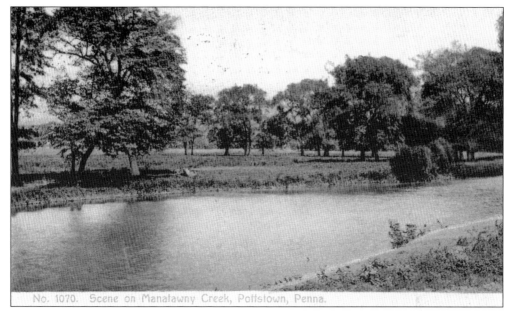

This is a 1907 view of the current Memorial Park. Many times over the years, the creek has overflowed its banks onto the lowlands, but it has always been rebuilt. It has been and still is a wonderful place for local sports. Every Fourth of July, a holiday celebration involving most of the town is held here.

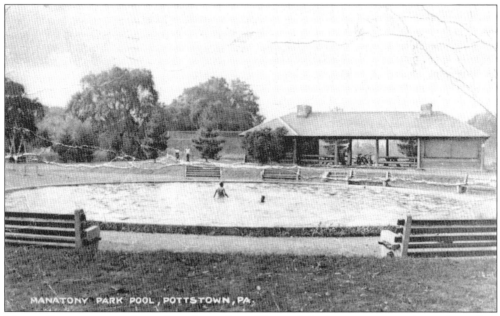

Many of us can remember when the only public pool in Pottstown was the park pool at Manatawny Park. It was not very deep, but it was a great place to cool off—that is, if there was not a polio scare. The pavilion, which still remains, is seen in the background.

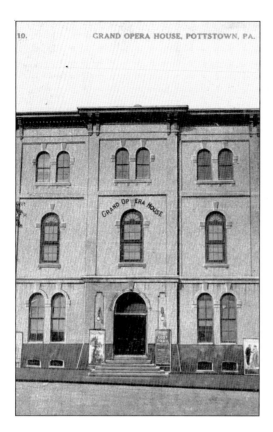

What town would be complete without its opera house? Posters announcing the performances are seen out front. Movies were held here after live performances were passé. One gentleman recalls that he went to the first talking movie there as a young lad. This building once stood next to the municipal building on the north side of King Street, where now there is a parking lot.

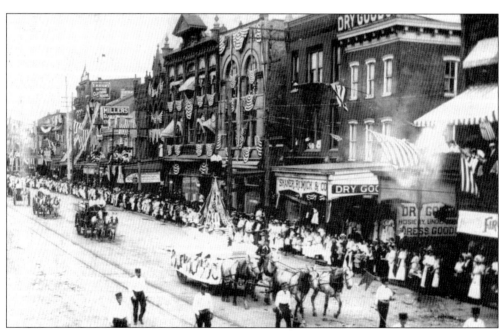

A parade from the beginning of the 20th century is seen here on High Street at High and Penn Streets. It is obviously patriotic in nature, judging from the bunting-draped buildings.

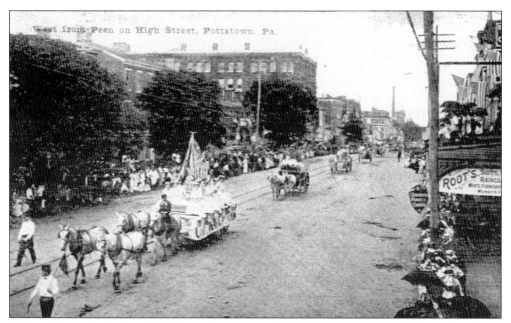

This early parade before 1910 is moving east on High Street as we are looking toward the Security Trust building. Even with magnification, it is impossible to discern what organization is being represented by the nearest float and its bevy of beauties.

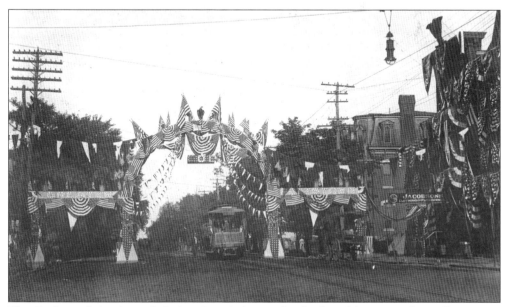

The Eagles arch is pictured during the 1912 Fourth of July celebration. The trolley is seen passing through.

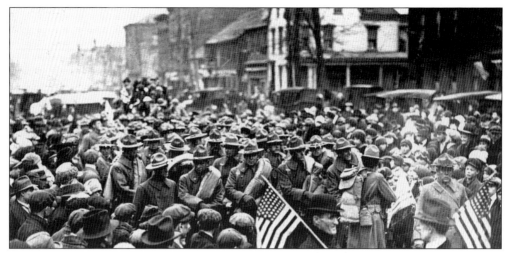

It appears that the whole town turned out to celebrate the home-town boys of Company A of the Pennsylvania National Guard on their successful return from the Mexican border skirmish in 1917.

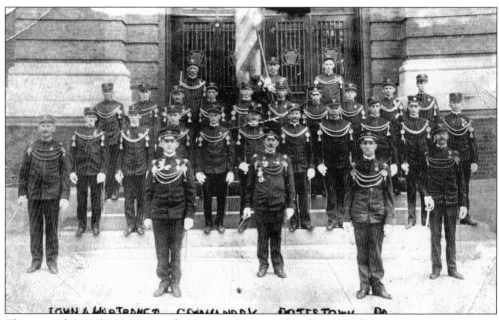

The men of the John A. Hartranft Commandery appear to be ready for a parade.

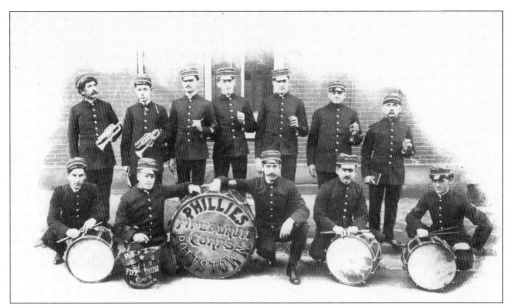

This is a picture of the Phillies Fire Company fife and drum corps. It appears that they, too, are all ready for a parade.

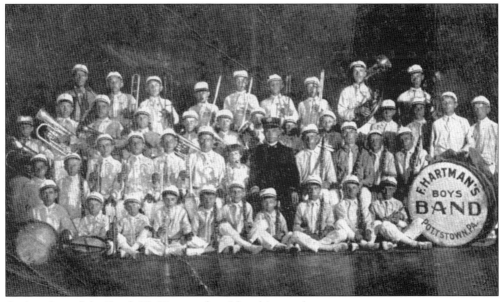

A nice view of the Frank H. Hartman boys' band is seen here.

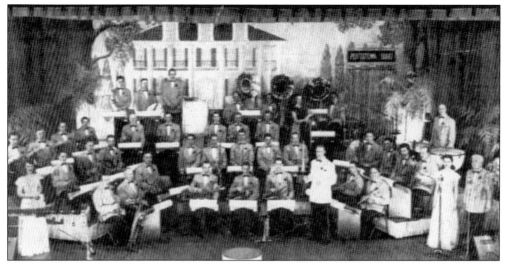

In more modern times, probably in the 1940s or 1950s, is the Pottstown band under director Bill Lamb Jr. The band's numerous summer engagements were printed on the reverse side of the card.

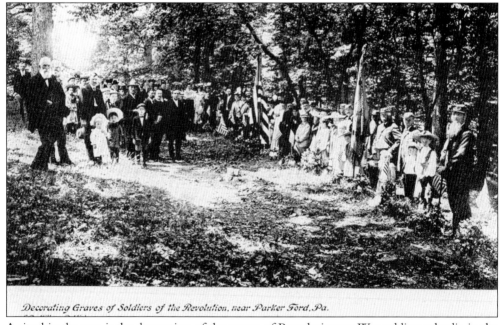

Decorating Graves of Soldiers of the Revolution, near Parker Ford, Pa.

A ritual in the area is the decoration of the graves of Revolutionary War soldiers who lie in the Ellis Woods Cemetery in East Coventry near the village of Parkerford. E. D. Miller was responsible for this pre–1907 photograph.

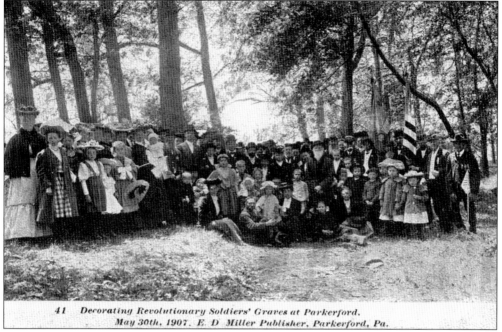

41 *Decorating Revolutionary Soldiers' Graves at Parkerford.*
May 30th, 1907. E. D. Miller Publisher, Parkerford, Pa.

This photograph by E. D. Miller was done on May 30, 1907, Decoration Day. We now know this holiday as Memorial Day, which is celebrated the fourth Monday of May. Note how formally these rural folks are dressed to give homage to fallen heroes.

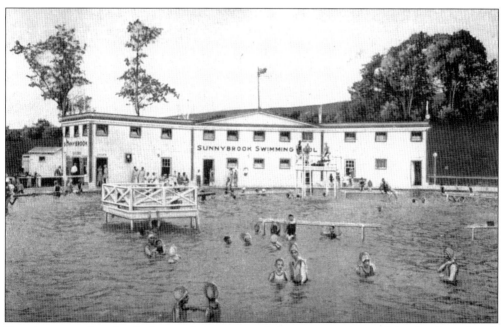

For those people who had enough money to belong to a private club, the Sunnybrook Swimming Pool was available for cooling on a hot summer's day. Sunnybrook Park had a playground and picnic areas where many family reunions and organization picnics were held. It is now defunct as a pool and is shown here on a postcard dated 1929.

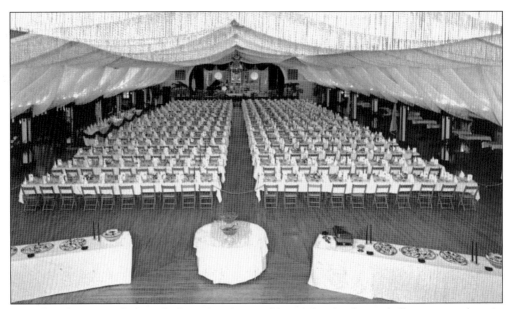

Sunnybrook was not famous for its swimming pool but rather its elegant ballroom, seen here in the 1960s. Many were the big band-era greats who played this gig. Crowds came to Pottstown from far and wide to enjoy this music and dance the night away. Also, Sunnybrook was made available for many high school proms. This image shows the stylish arrangement for one of many banquets held there. It remains a restaurant today.

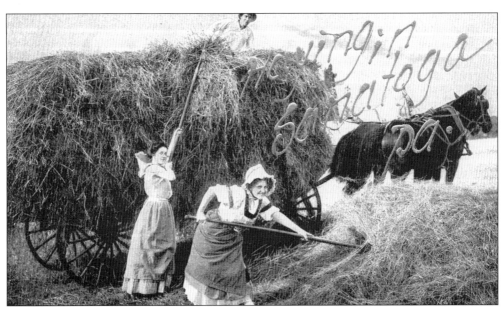

Another early recreational area was Sanatoga and its park.

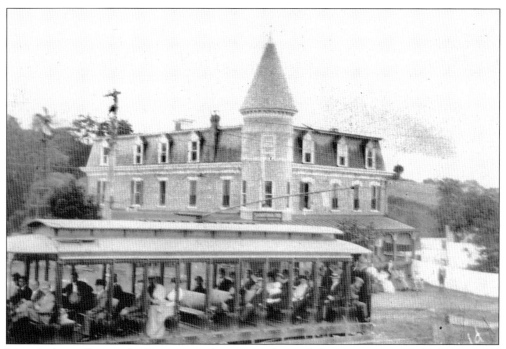

Here is the trolley to the Sanatoga Park. It is in front of the Sanatoga Inn, which remains a restaurant of note today.

The Lake Road.

The Lake Road leading to the park is pictured here. The lake was engineered in the late 1800s by G. F. P. Wanger, who was told that "it will never fill." He replied, "If it doesn't you don't owe me anything." It is presumed he was paid, as obviously the lake filled.

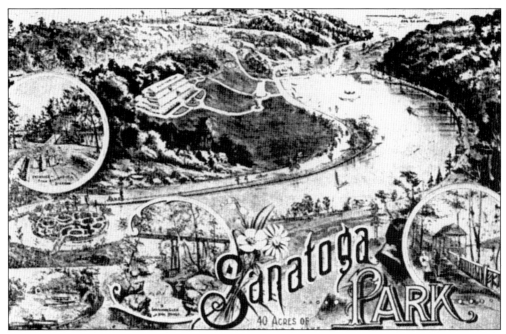

A very early advertisement for the park is shown here. The park was accessed by trolley or train.

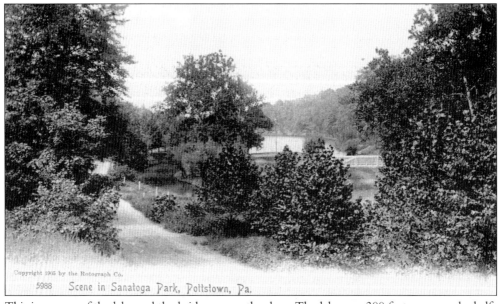

Copyright 1905 by the Rotograph Co.
5988 Scene in Sanatoga Park, Pottstown, Pa.

This is a scene of the lake and the bridge across the dam. The lake was 300 feet across and a half-mile long. There was boating and a swimming pool whose bottom was covered with sand and gravel. Diving boards, water slides, and other amusement devices were afforded to the more daring swimmers in this cool, exhilarating, and absolutely "clean" water. These were some of the enticements mentioned in a 1920s booklet about the park.

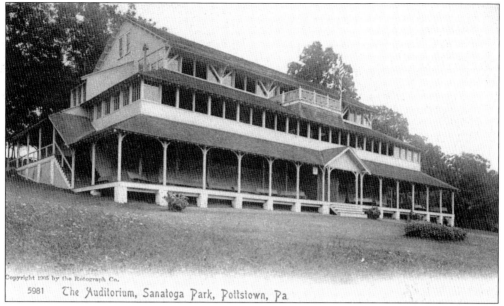

5981 The Auditorium, Sanatoga Park, Pottstown, Pa

The auditorium is seen here. It had a dance floor with an excellent orchestra featuring music in the afternoons and evenings, every day except Sunday. It could accommodate 2,000 people or more should it rain. Dancing carnivals, masquerades, and novelty dances were held here during the season. This information came from an advertising booklet in the 1920s.

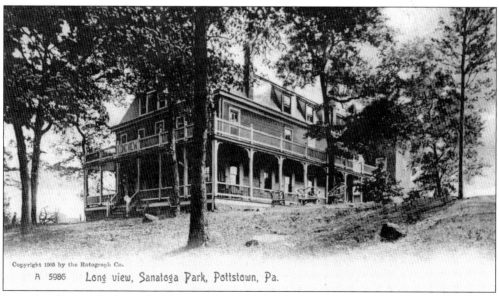

A 5986 Long view, Sanatoga Park, Pottstown, Pa.

Longview Resort is pictured in this 1905 card by the Rotograph Company.

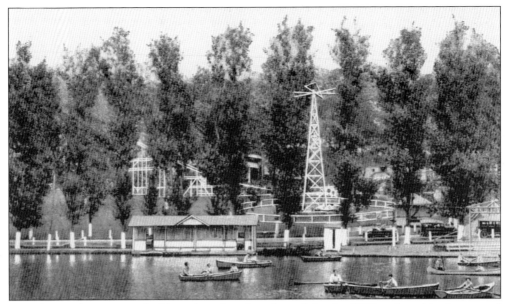

New forms of amusement had been introduced to the park by the 1920s, when this picture card was done.

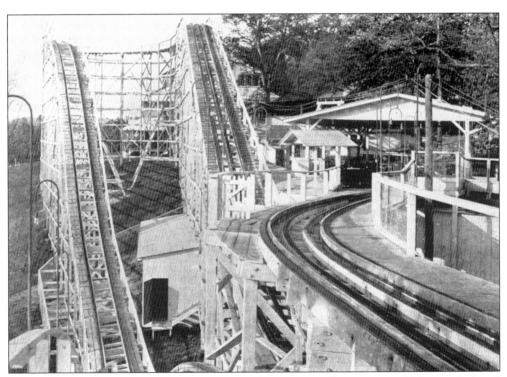

This is a closeup view of the one-mile-long Alpine Dips roller coaster, which was designed especially for the park by the famous Philadelphia Toboggan Company at a cost of $100,000.

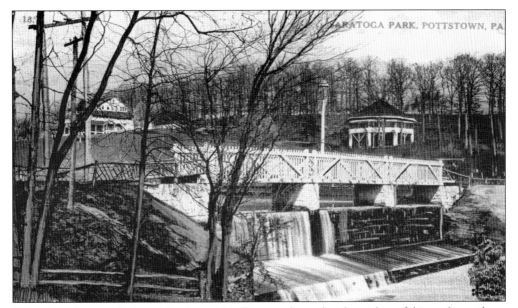

This early photograph shows the dam and spillway at the park. The maker of this card must have thought he was in New York State, as some cards are entitled Saratoga Lake, as is this one.

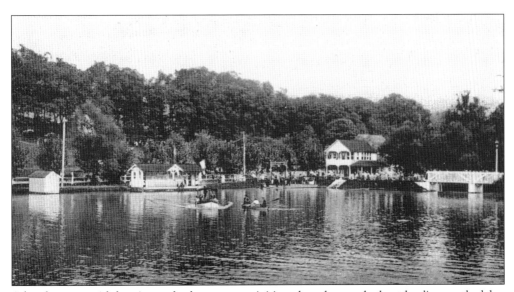

A lovely scene with boating and other water activities takes place at the boat landing on the lake.

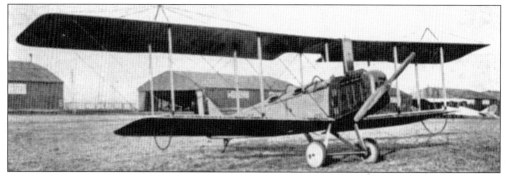

In the 1920s, a Curtiss airplane took many people on their first journey into the clouds. Note the open-air seating accommodating the pilot and two passengers in this biplane. Sanatoga Park eventually became an automobile speedway reaching its apex in the 1940s and 1950s. Neither the park nor the racetrack remain today.

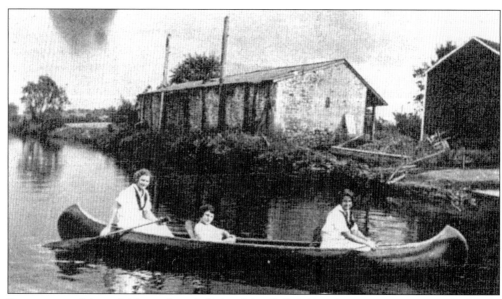

Pottstown and its neighbors also used the Schuylkill River for recreation. Over the years, however, the Schuylkill River fell from favor as industrial and coal pollution claimed it. In the early 1950s, the Army Corps of Engineers dredged the coal silt carried downriver from the northern coal fields in an attempt to clean up the river and make it once more attractive to native fish and for human recreation. In this picture are several ladies boating on the Schuylkill Canal in the 1920s.

Seven
OUR HOMES
AND VILLAGES

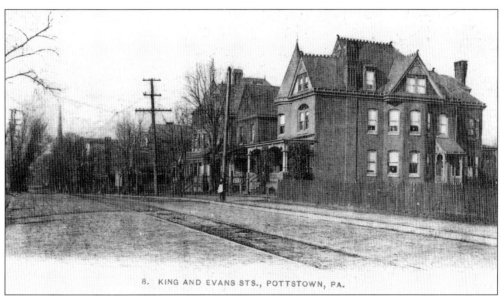

8. KING AND EVANS STS., POTTSTOWN, PA.

This is a 1906 picture of homes at King and Evans Streets, on the north side of King Street. The view looks toward Charlotte Street. The church spire in the left distance is that of the Trinity Reformed Church. The new Baptist church has yet to be built at King and Charlotte Streets. King Street was a cobblestone street with trolley tracks. The cobblestones were replaced in the late 1940s. This chapter features more of the outstanding homes captured in postcards in Pottstown and the villages of the area.

In this view, looking north up Franklin Street, are the lovely mansions that stood at the corner of King and Franklin Streets. The first was torn down for the construction of the American Legion building. A few doors in were the offices of Dr. Russell Ash and Dr. Jacob Shade in later years.

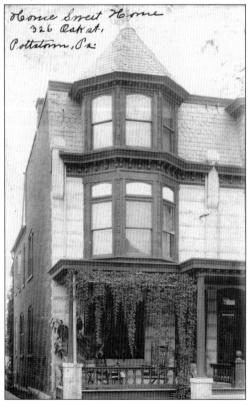

A nice Victorian home with a mansard roof is shown here at 326 Oak Street. Note the Boston ferns and the comfortable-looking porch.

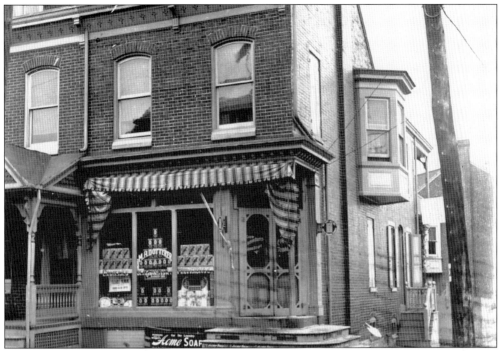

Here we see the corner grocery store at North Charlotte and Oak Streets. In the 1940s, penny candy could still be purchased here.

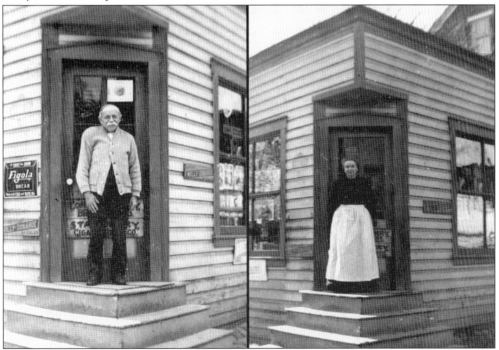

This delightful little corner store stood at the intersection of North Evans Street and Lincoln Avenue for many years. It is assumed that these folks are the proprietors. The building is still standing but no longer serves as a store.

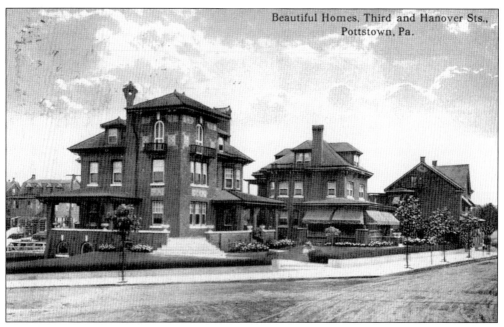

More modern homes in town are these beauties on North Hanover Street, seen *c.* 1920. The first one was razed for a parking lot.

In North Coventry Township on the way to the village of Cedarville is the intersection of Laurelwood and West Cedarville Roads *c.* 1910. The homes pictured remain today, but fortunately the muddy road is gone.

This is another old Chester County farmhouse at the northwest corner of Laurelwood and Cedarville Roads. The picture is from the 1920s, and this home also remains standing but without the porch.

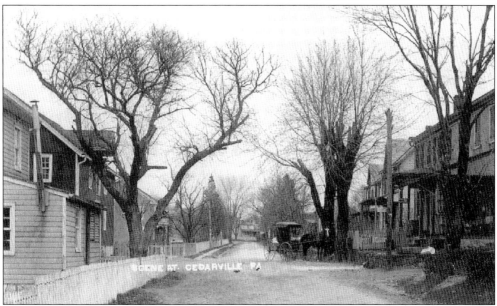

The Cedarville General Store serving the small village is seen on the right in this view looking east. Many children from the village and elsewhere walked or bicycled to the store, clutched their coins, climbed the steps, heard the familiar jingle as the door opened, and waited for Erma or Ruth to serve them penny candy from those lovely glass dishes. The store served its customers for over 100 years. The remaining contents of the store were sold at auction in May 2001. The store has since been converted into a private residence.

Today, on Route 724 is a large modern shopping mall. This magnificent home, built in the mid-1800s by Abraham Wanger, once graced the area until the mall came. It was his son George who donated the land to the Cedarville Methodist Church, although he was not a Methodist. George served in the Civil War but, more importantly, provided shelter for runaway slaves as part of the Underground Railroad.

This was the smokehouse and bake oven for the farmhouse just seen. It, too, is gone. The township was able to salvage the wooden floors from the big house before demolition occurred, and they have been utilized as paneling in the township building meeting room.

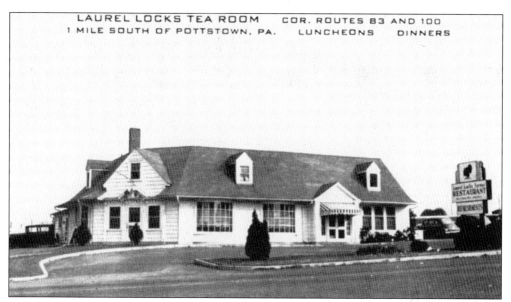

LAUREL LOCKS TEA ROOM COR. ROUTES 83 AND 100
1 MILE SOUTH OF POTTSTOWN, PA. LUNCHEONS DINNERS

Laurel Locks Farms opened a tearoom in the 1950s on South Hanover Street. The area where it stood is now a doctor's office associated with the Pottstown Memorial Medical Center.

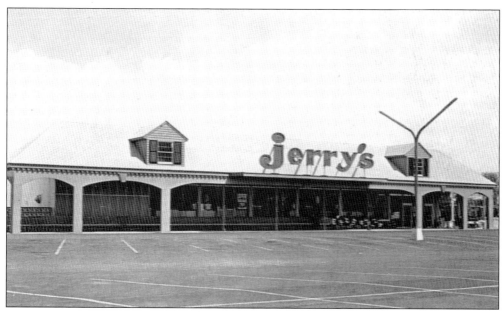

Many residents shopped for groceries at Jerry's, a modern supermarket built in the 1950s. This is a Gene Orlando card from *c.* 1960. The store, located on South Hanover Street, saw a few changes of hands over the years until its final closing. In 2003, the entire complex was torn down for a new, larger mall and grocery store.

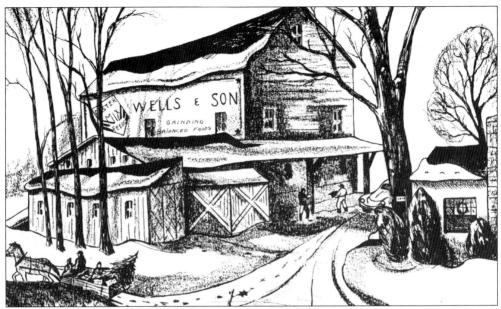

The largest village in East Coventry was and still is Parkerford, which was originally called Lawrenceville. This name was applied to honor Andrew Lawrence, an engineer in charge of constructing the local locks of the Schuylkill Canal. The village grew very profitably as a result of the canal. In 1883, the Pennsylvania Railroad changed the name of the village to Parkerford; there was a Lawrenceville in Tioga County. Henry Parker was an early-18th-century resident of the area near the river and the ford then known as Parker's Ford. Edward Parker had a tavern in the area. Approaching Parkerford on the Schuylkill Road, the Wells and Son feed mill stood near the railroad crossing at Wells Road. This drawing was done by Trudy Eyerhard on a note card from the 1940s.

The next few cards depict Parkerford as it was in the early 1900s. Many of the homes remain today. This is a view of River View Farm.

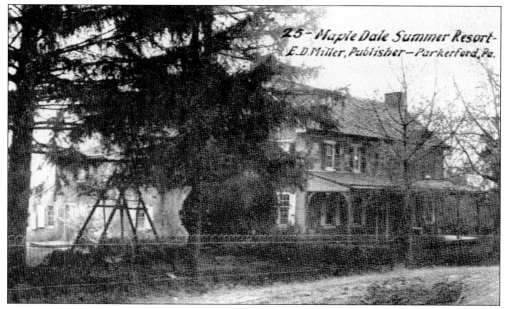

In this pre-1907 card, the place we just saw was then called Maple Dale. The writer of this postcard says it was a lovely place to stay and that she will hate to go back to Philadelphia after a week's stay.

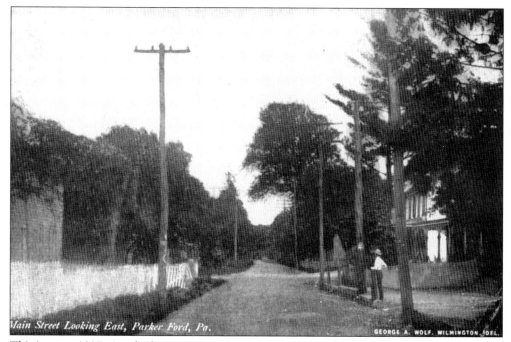

This is a pre-1907 view looking east on what is now old Schuylkill Road. Remember it was the only road then; Route 724 did not exist. Bethel Church Road is the crossroads seen.

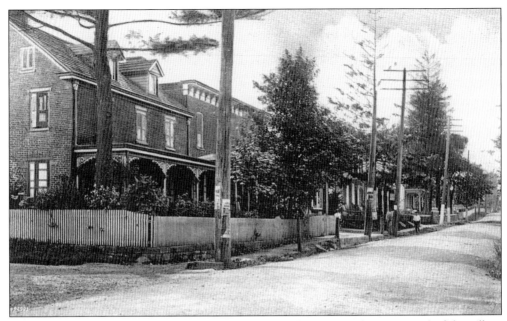

This view from the middle of Bethel Church Road looks west on the main road of the village of Parkerford.

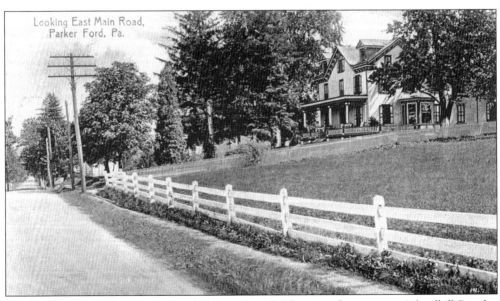

This lovely old mansion is seen in a 1914-dated card. The view faces east on Schuylkill Road.

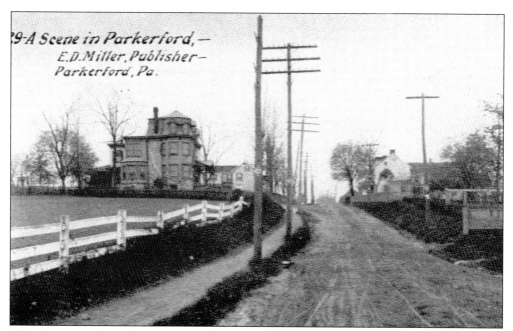

This view was taken from the Schuylkill Road, looking west toward Baptist Church Road, which goes off to the left before the house.

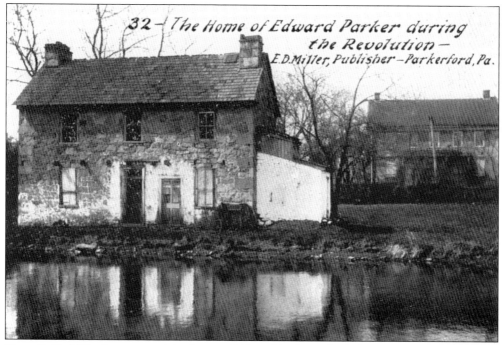

Here, E. D. Miller has captured the home of Edward Parker, which dates back to Revolutionary War times.

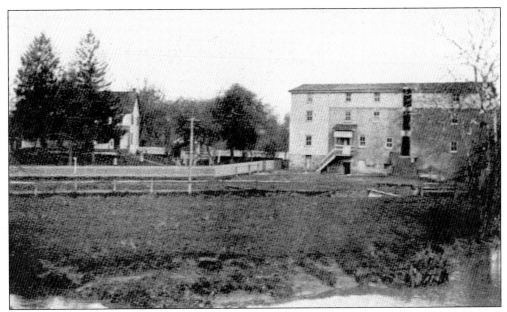

Seen here is S. T. Wagner's mill, on Bethel Church Road just outside the village of Parkerford.

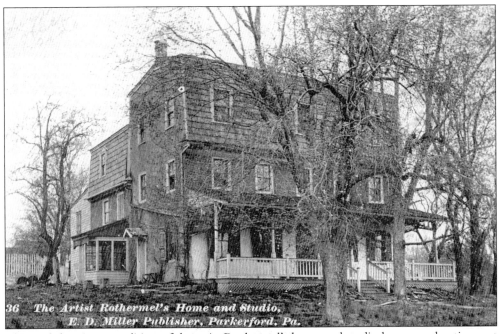

This card showing a rendition of the artist Rothermel's home and studio bears an advertisement on the back. The advertisement, by E. D. Miller, says he will have the 43 pictures in his postcard series available at the Eureka Hall. Other goods will also be available, such as Larkin products, Bibles, books, *Ladies World* (a magazine), and many other items.

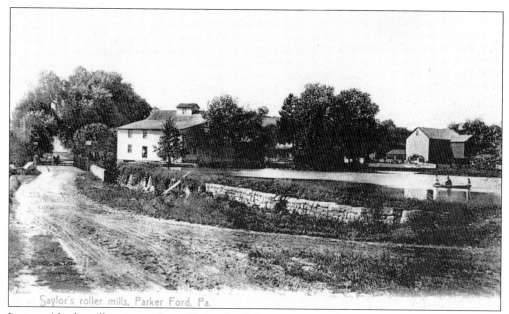

Saylor's roller mills, Parker Ford, Pa.

Just outside the village is another mill that lends its name to the road on which it is located. This would be Saylor's Mill.

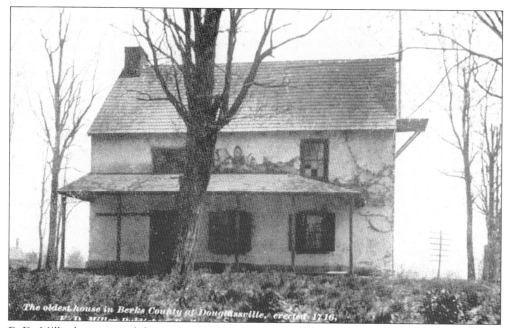

The oldest house in Berks County at Douglassville, erected 1716.

E. D. Miller has captured the Mounce Jones house in Douglassville on this early card. The house was built by the early Swedes in the region, who called that area Morlatton.

ACKNOWLEDGMENTS

I must thank my son, Todd Moyer, for his sharing with me another book in this series and his urging me to do one on Pottstown. I also thank my friend Kathryn Ballein for her patience and help during the writing period. My sincere thanks are extended to Charles Moyer, a friend since the third grade, who graciously permitted me to use some of his wonderful postcards in this book. Much of the real credit goes to those early photographers who captured life as it was in the first half of the 20th century. My deep admiration and acknowledgment also goes to Estelle Cremers for her wonderful book on the Coventries and to Paul Chancellor and Marjorie Potts Wendell for their book on Pottstown. Both books were indispensable for facts and dates. David Kerns of the Pottstown Historical Society has been a wonderful resource person.

My postcard collection began with a few family cards given to me by my uncle, and my contacts through the antiques business world have allowed the collection to grow over the years. My grandfather passed away one month before my birth, but I must thank him for my history-loving genes, for surely they must have come from him.